THE
YIN/YANG
OF
PAINTING

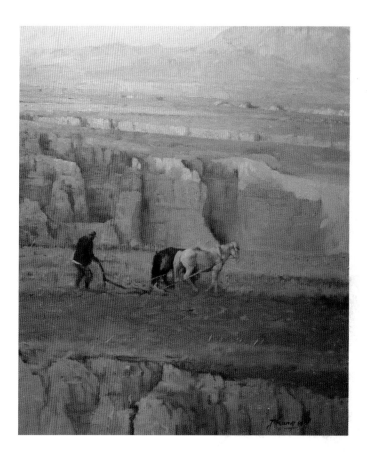

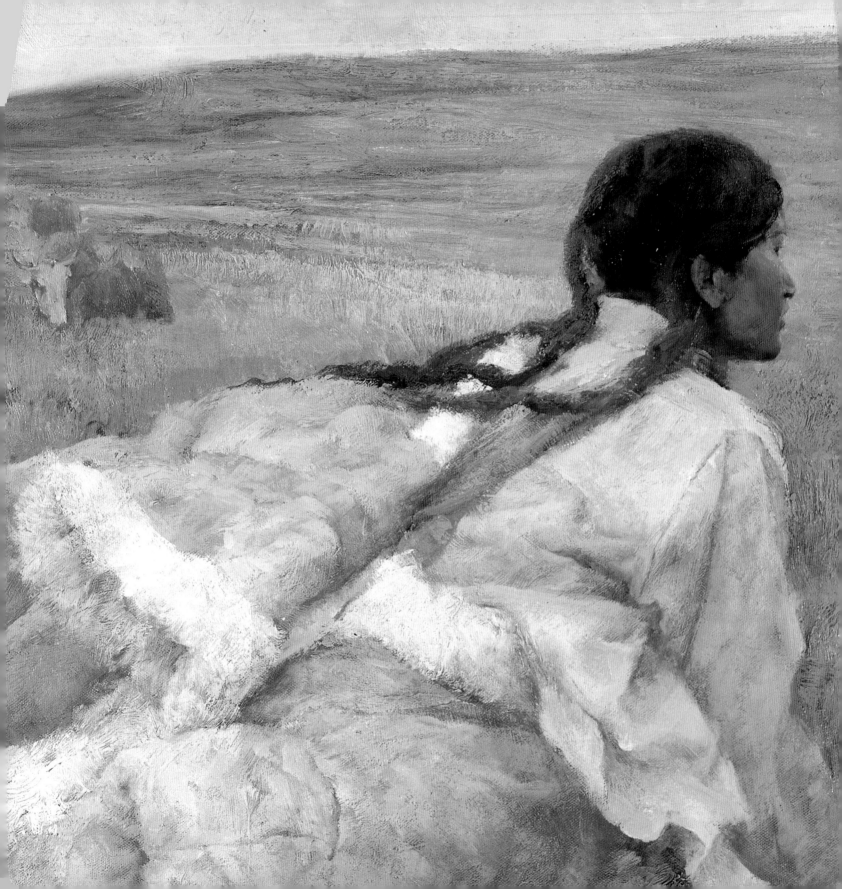

THE YIN/YANG OF PAINTING

A Contemporary Master
Reveals the Secrets of
Painting Found in Ancient
Chinese Philosophy

☯

HONGNIAN ZHANG
AND LOIS WOOLLEY

WATSON-GUPTILL PUBLICATIONS
NEW YORK

FOR OUR PARENTS,

XUE BIN AND XIU QING ZHANG AND

HAROLD AND RUTH WOOLLEY,

WHOSE POSITIVE INFLUENCES NURTURED OUR SOULS.

Front cover:
ANEMONES
24 × 20" (61 × 51 cm)

Frontispiece:
THE WARM EARTH
24 × 20" (61 × 51 cm)

Title page:
DREAM OF TIBET (detail)
24 × 30" (61 × 76 cm)

Acknowledgments

We would like to thank our dear friend Martha for her patient reading of our early manuscript. Thanks also to Tom Fletcher of Fletcher Gallery and James Cox of James Cox Gallery (formerly of Grand Central Gallery) for their assistance in procuring transparencies for this book.

All paintings in this book have been sold into private or corporate collections, with the exception of *Renee and Mozart,* which remains in the collection of the artist.

Senior Acquisitions Editor, Candace Raney
Edited by Robbie Capp
Designed by Areta Buk
Graphic production by Ellen Greene
Text set in 11-pt. ITC Garamond

First published in 2000 by Watson-Guptill Publications,
a division of BPI Communications Inc.,
770 Broadway, New York, NY 10003

Library of Congress Card Number: 00-103864

Manufactured in China

First printing, 2000

1 2 3 4 5 6 7 8 / 07 06 05 04 03 02 01 00

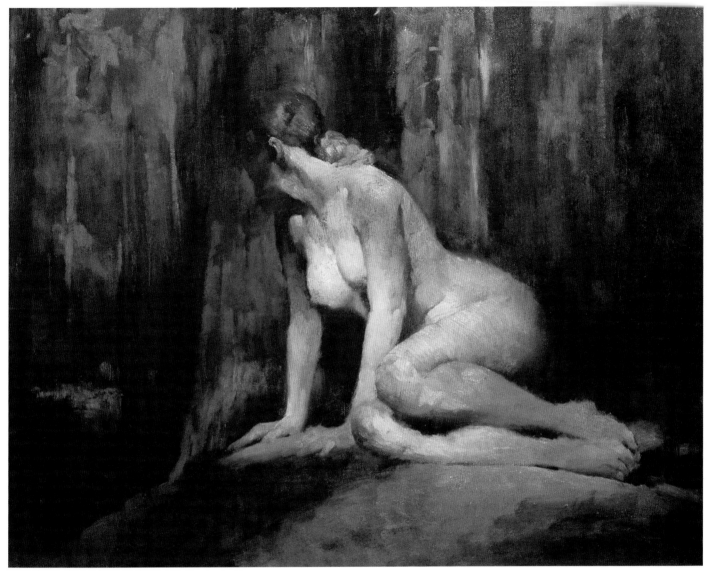

MOONLIGHT

16 × 20" (41 × 51 cm)

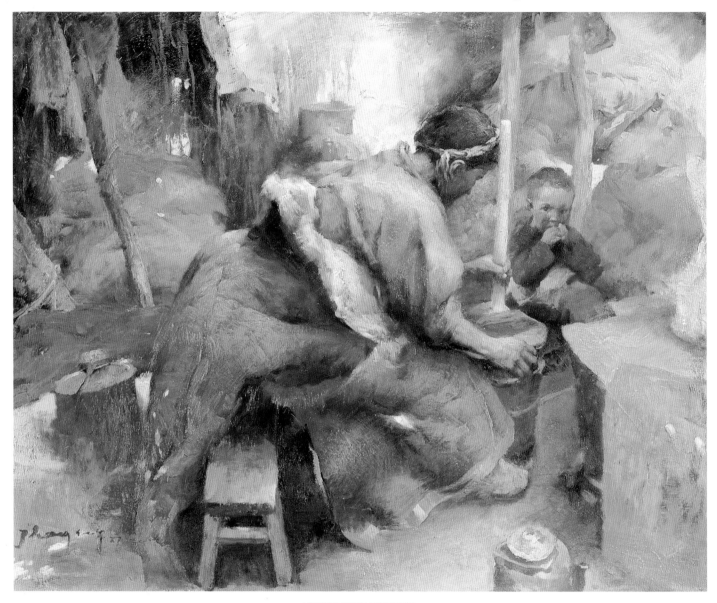

CHURNING BUTTER

24 × 40" (61 × 101 cm)

CONTENTS

TIBETAN BOY

19 × 15" (48 × 38 cm)

TIBETAN GIRL

20 × 16" (51 × 41 cm)

PREFACE

In welcoming students to a recent three-day workshop, I greeted them with these words: "Day one, we study spelling. Day two, we write a sentence. Day three, we write a novel."

My students laughed. After all, this was a *painting* workshop. Yet, my choice of words was accurate, because art is a language. What is most important is what you want to say—what story and point of view you want to share.

When I look back over the paintings in this book, I hear them telling their stories, one by one. As varied as the subject matter, they are actually all about my life.

I remember the first time I saw the endless Tibetan highlands. China's Cultural Revolution had so drained me spiritually that this timeless, peaceful place made my heart ache. This inspiration for subject matter followed me from Beijing to New York as a song without words.

A similarly deep feeling rose in my heart when I visited Plimoth Plantation, in Massachusetts. In my struggle to emigrate to America, I had lost my wife and faced an uncertain future in this New World. The courage and sacrifice of this nation's early immigrants, the Pilgrims, seemed to be my story, too. My paintings about them, inspired by the reenactment of seventeenth-century life in that New England village, are witness to their struggle, and also to my own.

As a single parent raising a young daughter, my life was difficult without a woman's touch. To create my spiritual support, I painted angels as a symbol of the female tenderness and strength that I missed so dearly.

Contemporary American subject matter only recently entered my paintings. It took so long because I didn't feel "in there" until Lois, the principal writer of this book, came into my life. With her, I am married to American culture, and feel inspired by it. My brush is now charged by my love for this era of my life.

We live surrounded by trees and wildlife in Woodstock, New York. This town is steeped in American art history, and we are proud to be part of its continuing heritage. The natural surroundings are an ever-present inspiration for new works.

I never consciously plan my subject matter. Whatever I paint, my paintings all have a common point of view. To me, the world is forever young. Each generation is followed by a new one. So, when selecting subject matter, I strive to keep my heart and eyes wide open, to see the world with the innocence of a child.

HongNian Zhang

张红年

INTRODUCTION

The ancient Chinese dualistic philosophy of yin and yang is a way of explaining our world in terms of a balance of opposites. All entities include their opposite as part of their nature. Two things that are against each other also support each other in a balanced relationship. The back of your hand cannot exist without its palm. Up implies down, hot implies cold, black implies white, and so forth. Positive forces require negative forces, and energy is released by their balance.

Good paintings always exude an energy that flows from a harmonious balance of contrasts. Opposites pull and push, and the successful artist learns to control them to his or her advantage. Thus, yin/yang theory applies to every element of art—from value and color to composition and movement. It connects drawing with painting, and makes peace between the separate realms of abstraction and representation. Using this system, it becomes easier to understand such difficult concepts as neutral color, and to explain what causes painted passages to appear muddy or chalky.

While the words *yin* and *yang* have many meanings in Chinese, the most common one for yin is shadow, and for yang, light—terms that apply directly to rendering form in paint. This concept is represented graphically in the ancient yin/yang symbol shown above and in interpretations of it elsewhere in this book.

As discussed and illustrated in the chapters ahead, the traditional elements of painting and the related yin/yang pairs that govern them are:

ELEMENT	YIN/YANG PAIRS
VALUE	DARK/LIGHT
COMPOSITION	UP/DOWN, LEFT/RIGHT, FRONT/BACK, BIG/LITTLE
COLOR TEMPERATURE	COLD/WARM
COLOR INTENSITY	SOFT/STRONG
COLOR HUE	GREEN/RED, PURPLE/YELLOW, BLUE/ORANGE
TEXTURE APPLICATION	THIN/THICK
PAINT QUALITY	TRANSPARENT/OPAQUE
BRUSHWORK LENGTH	SHORT/LONG
BRUSHWORK SPEED	SLOW/FAST
BRUSHWORK EDGES	BLURRED/SHARP

All of the above yin/yang concepts are explored in the pages that follow, and our concluding chapters apply them to specific subject matter in detailed demonstrations of still life, landscape, and figure painting. At the back of the book you will also find a list of oil paint colors and other materials that we recommend.

We use the ancient Chinese yin/yang philosophy in this book to help you develop a way of thinking that will result in better paintings. Whether you are a beginner or an experienced artist, we hope that exploring these concepts will further the enjoyment and success of your work.

AUTUMN LEAVES

20 × 16" (51 × 41 cm)

The words yin *and* yang *have many meanings in Chinese, but the most common one for yin is shadow, and for yang, light—qualities that are featured in this painting.*

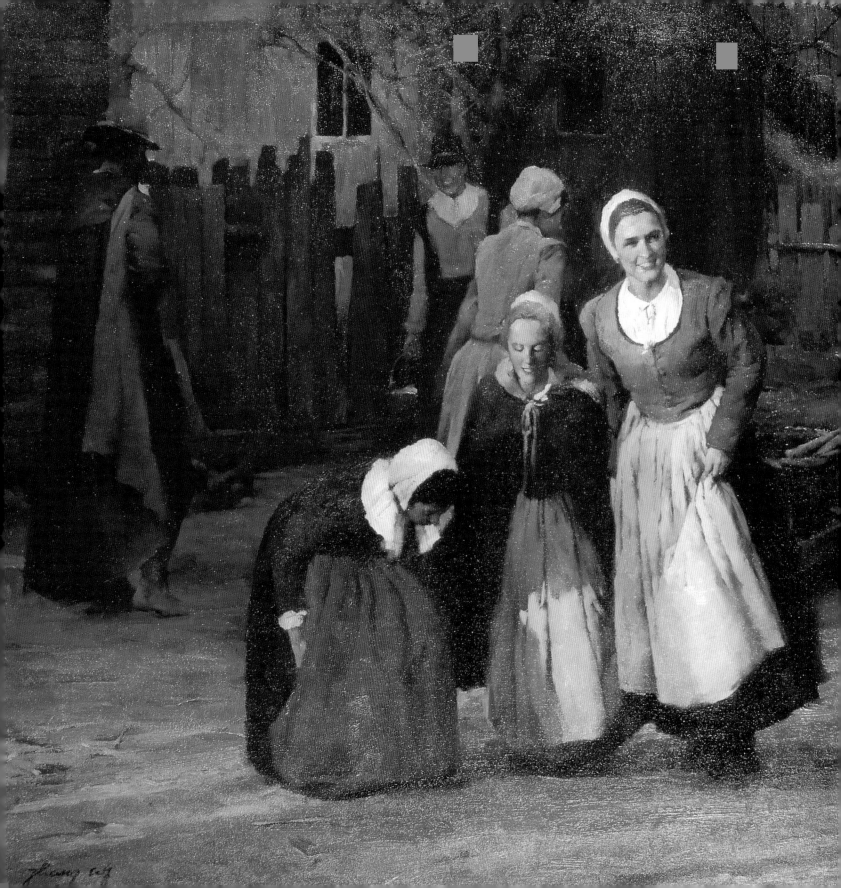

VALUE

GREETING IN THE VILLAGE

30 × 40" (76 × 101 cm)

This painting exemplifies the yin/yang of dark/light values. It was inspired by my visit to Plimoth Plantation. I have found America to be a place filled with cheerful, down-to-earth, hard-working people, and I believe this has been true since the earliest settlers. As an immigrant myself, I wanted to show the positive feelings that kept the Pilgrims going in the face of so much adversity. This contrast of hope and dreams versus austerity is symbolized by the extreme chiaroscuro.

CONTRASTS

The contrast of black (yin) and white (yang) is the most basic yin/yang element in visual art. It forms our first impression of an image. A painting filled with light values inspires feelings of openness, good spirits, energy, youth. We will refer to these as *yang* paintings. Conversely, the dark, or *yin*, painting is dominated by dark values. Yin paintings emanate mystery, melancholy, solemnity, significance.

In yin/yang theory, all things contain their opposites. In the same vein, yang paintings always contain yin elements, such as a dark passage supporting a larger field of light.

VALUE STUDY

Most areas of this painting belong to the light value pattern, making this a yang painting. Only the woman's apron and the shadow on the fence are of dark value.

ON THE ROAD
24 × 30" (61 × 76 cm)

This Tibetan woman's dress, and most of the background, are painted in similar high-key values. These light, yang areas are felt more keenly because of the narrow, twiglike dark pattern.

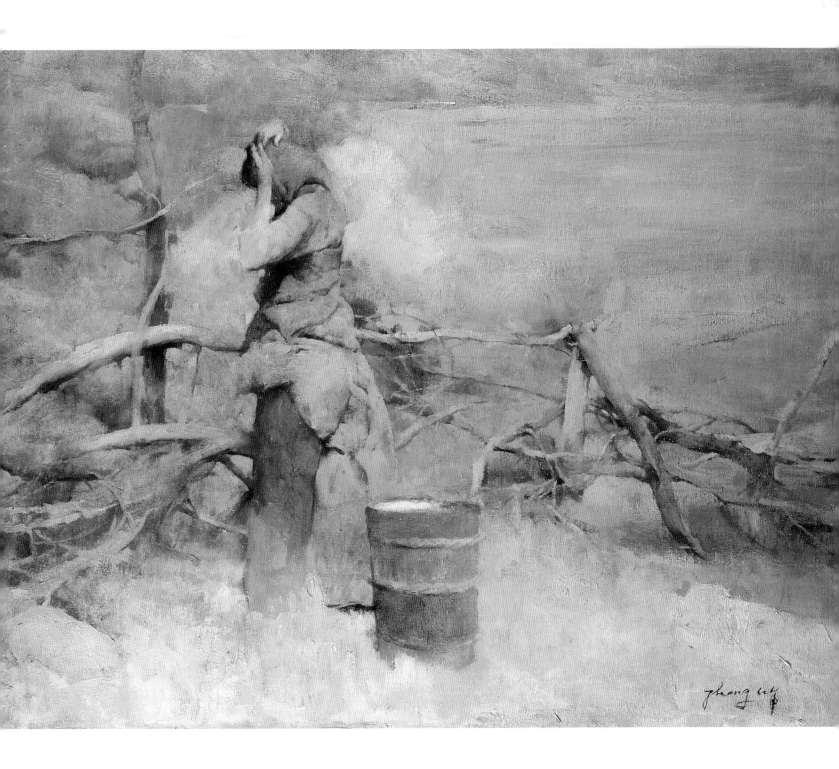

15

PORTRAIT OF ELIZABETH

74 × 80" (188 × 204 cm)

An example of a dark, or yin, painting, the combination of a dark expanse of paneled wall, iron staircase, and an antique desk give this scene a serious mood. The light areas of the figure dressed in wedding attire, her dog, the floor, and the gleam on the curved railing glow in dramatic contrast. These points of light make the deep yin tones richer.

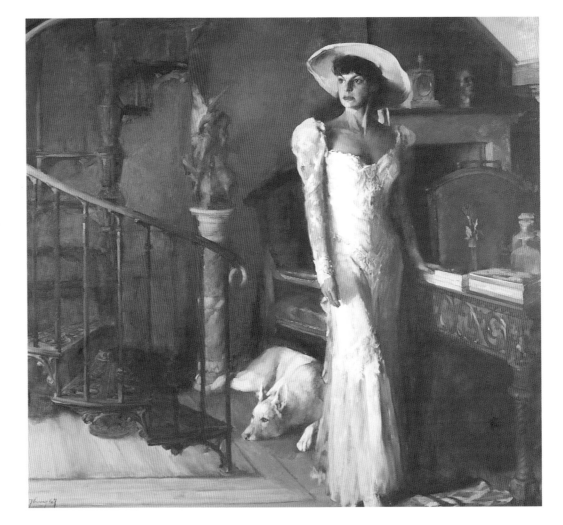

VALUE STUDY

It is evident that this painting's greatest area belongs to the dark pattern. Only the woman, her dog, and a small part of the background are light valued.

VALUE RANGE

Values range through many subtle steps of gray, between black and white.

In the light (yang) painting, the dark pattern creates the visual excitement, while in the dark (yin) painting, it is the light pattern that catches the eye.

The shades not close to either black or white are called middle values. These are the most sensitive part of a painting. Middle-value areas have a keen influence on a painting's mood, since they often occupy a significant portion of the canvas, and color is experienced more readily in the middle-value range. Yet, they need to be controlled carefully in order to keep the composition strong.

How can this be done? By interpreting the middle value as belonging to either the dark or the light pattern. In a yin painting, the middle-value tones are pushed down a step to link them to the dark values. In a yang painting, the middle values are interpreted a step higher in key to connect them to the light areas.

VALUE CAN GUIDE COMPOSITION

Designing the painting's composition by its pattern of values frees us from a strict interpretation of individual objects. This kind of pattern always crosses the borders of objects, combining the value of local colors with the effects of lighting. Such unification gives the painting a simpler and more powerful construction, and thus is a very important element in good composition.

Another real advantage in this approach to composition is the opportunity to strengthen the emotional message with subliminal cues. We use the abstract pattern's shape to suggest the underlying feeling we intend the viewer to experience, as in *Magnolias* (page 21).

THE *CHI* RHYTHM OF A PAINTING

The movement in a painting is the path your eye takes to observe the highlighted pattern. This visual path is the energy, or *chi* (pronounced "chee"), of the painting. Just as negative and positive charges work together to spark the movement of an electrical motor, the opposing forces (yin/yang) governing space and position spark the visual movement in composition. These forces are big/little, down/up, left/right, and back/front.

Nature always seeks a balance; it abhors a vacuum. In the same way that water in a reservoir will push against and overflow its dam, the eye moves when the motif pattern is larger in one place and smaller in another. It doesn't always travel from big to little; sometimes it travels from little to big. Your eye is drawn to, and will move along, the pattern's deviations, be they up, down, left, right, or in spatial depth, back or front.

A strong composition always has movement, otherwise it has no *chi*. But movement patterns can vary greatly. For example, the busy, staccato rhythm of *New Home* (page 23) is very different from the gentle, rippling wave in *Dreaming at Noon* (page 24).

VALUE STUDY

This study clearly shows how the middle value is more closely linked to the light values than to the dark ones.

THE OLD STORY

28 × 32" (71 × 81 cm)

This painting is cast in light tones to show the warm feeling of the sunlight and family connection. The boy and his grandmother, the butter churn, saddle, and ground are interpreted in a higher key than they appeared in life. In this way they are connected with the lightest-colored objects: the child's white sleeve, the fur trim on the leather cloaks, the grandmother's hair, and the churn stick.

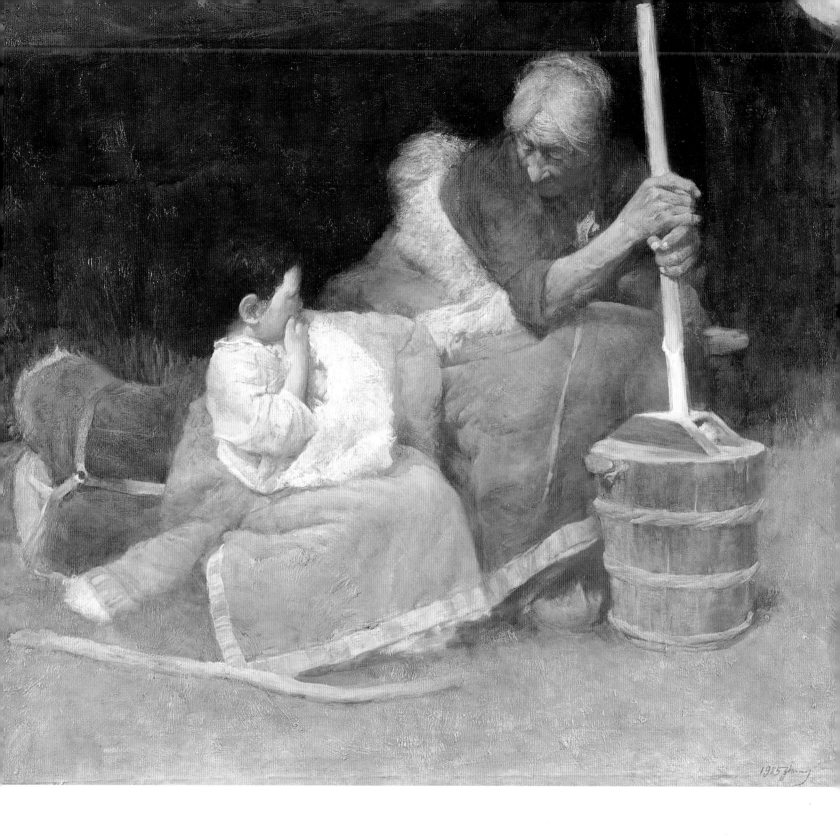

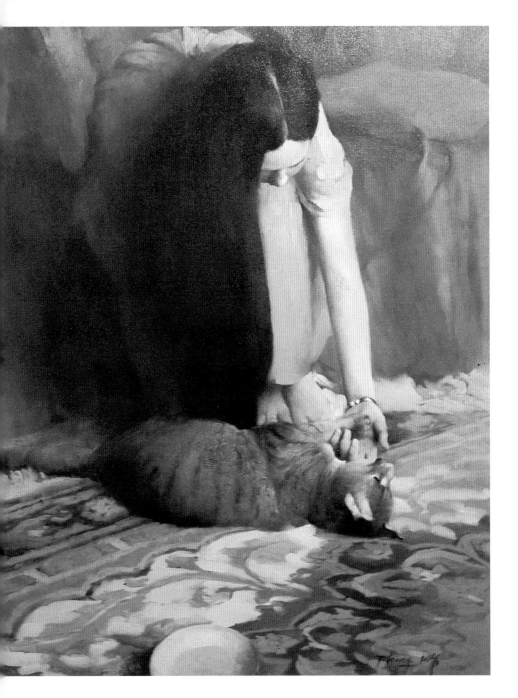

VALUE STUDY

The dramatic gesture of Renee's extended arm is spotlighted, as revealed in this value study of the painting's underlying composition.

RENEE AND MOZART

30 × 24" (76 × 61 cm)

Here, the middle-value areas were painted somewhat darker than they appeared in life. Most of the oriental carpet, cat, sofa, and the back of Renee's dress are dark middle values that melt into her sweep of black hair. This creates a mysterious and magical dark atmosphere that accentuates the lighter colors of her face and arm, the lavender streak of her gown in the light, and the cream-colored arc in the carpet's design.

VALUE STUDY

❧

A dark pattern reminiscent of Chinese calligraphy strengthens the suggestion of elegance that characterizes this scene.

MAGNOLIAS

40 × 30" (101 × 76 cm)

❧

Viewing this painting might evoke an unconscious association with Chinese calligraphy—a calm, poetic elegance. The same feeling of refinement and poise is experienced consciously in viewing the girl's dress and pose. The middle values of the girl, her decorative clothing, the magnolia blossoms, and background meadow are all lighter than in reality, as if they were the rice paper for handwritten romantic poetry.

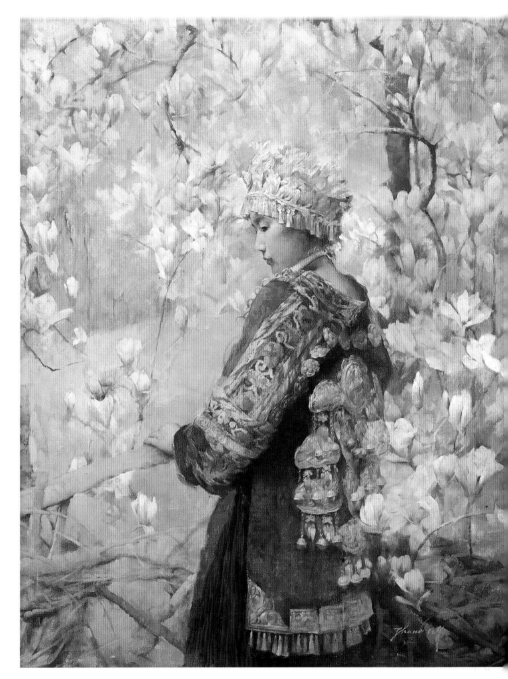

END OF THE DAY
25 × 36" (64 × 92 cm)

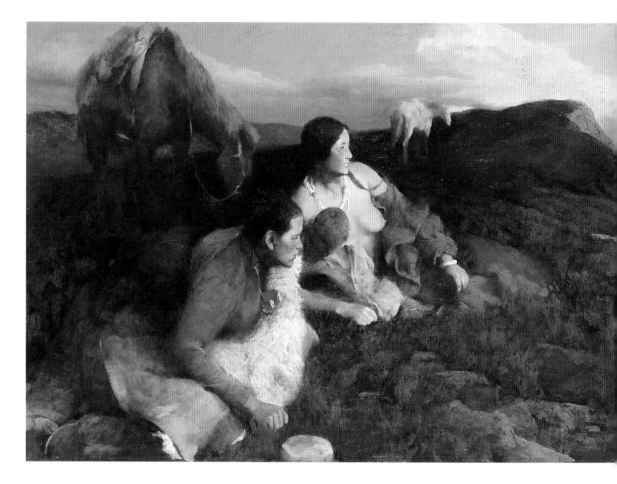

The compositional pattern of this painting metaphorically suggests its mood. The middle values have all been pushed down to merge with the darks. Together they form a larger yin backdrop that dramatically displays the abstract light motif. The darkened sky, cliff, horse, and clothing all melt into the dark pattern. The light pattern consists of the fur collar, the man's face, the woman's face and torso, the white horse, and the clouds.

VALUE STUDY

Observe how the light pattern starts from the lower left, and, crossing several figures and objects, twists and rises to the upper-right corner. Its shape suggests a swirling trail of campfire smoke, which is consistent with the quiet, dreamy mood of a family gathered around a campfire between dusk and nightfall.

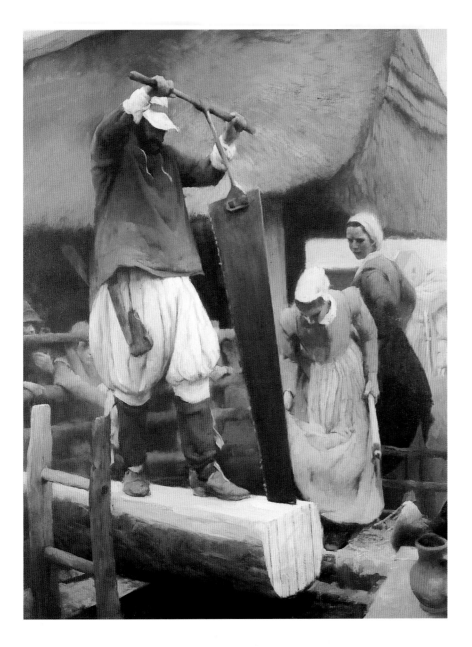

VALUE STUDY

Since this is a dark (yin) painting, the major movement is the light-valued pattern. The sharp up/down movement echoes the strokes of the saw.

NEW HOME

40 × 30" (101 × 76 cm)

The powerful movement of the man sawing wood is enhanced by the rise and fall of its light-value pattern. This pattern starts from the patch of light on the ladder in the lower left, rises up the man's pants, and skips to his hat. It then turns sharply down with a highlight along the saw's edge, and drops to the U-shaped end of the log. Then the visual path abruptly jerks right and moves up to the girl's apron, the women's bonnets, and the sky above.

23

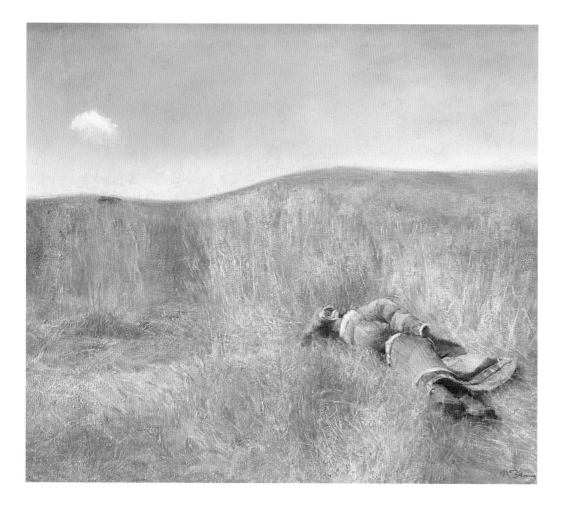

DREAMING AT NOON

20 × 24" (51 × 61 cm)

The visual path in this high-key painting tiptoes from right to left along the delicate shadows of the sleeping boy. One's eye then hops to the path through the tall grass and climbs the hill to rest in the cast shadow of one lonely cloud. This lilting movement echoes the floating quality of a dream.

VALUE STUDY

Like a gentle, rippling wave, this light painting has a quiet movement from lower right to upper left, following the darks in the figure and the path, ending with the tiny cloud's shadow.

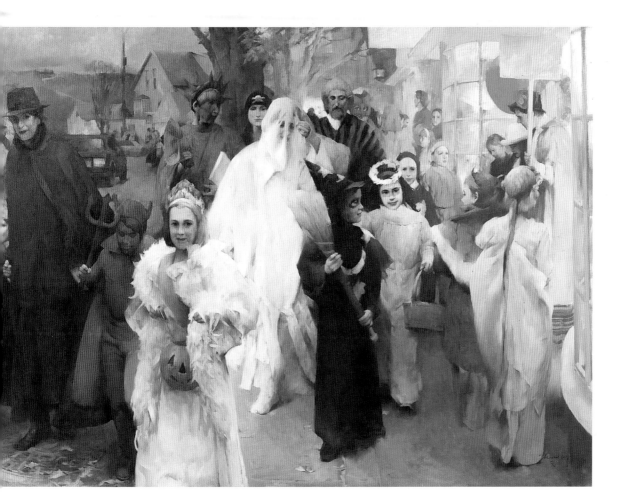

These figures feel three-dimensional because their forms show sides facing the light or turning into the shadow. The accurately depicted transition from light to dark is what makes them feel so real. The relationships among these forms also present a sense of space. For instance, the contrast from shadow to light is strong on figures in the front, or focal, area, but wanes for more distant figures. The yin/yang of value also helps to form their shapes. The figures enveloped by twilight are in a dark pattern that supports the shape of the white-dressed figures. These light figures in turn support the dark figure of the little witch.

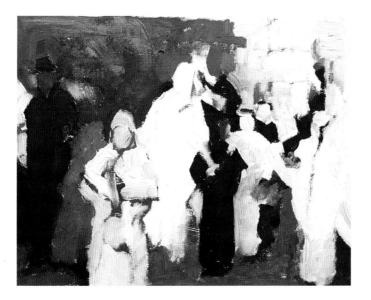

VALUE STUDY

The transition of values from light to dark and the contrasting values of adjacent shapes heighten the sense of three-dimensional form.

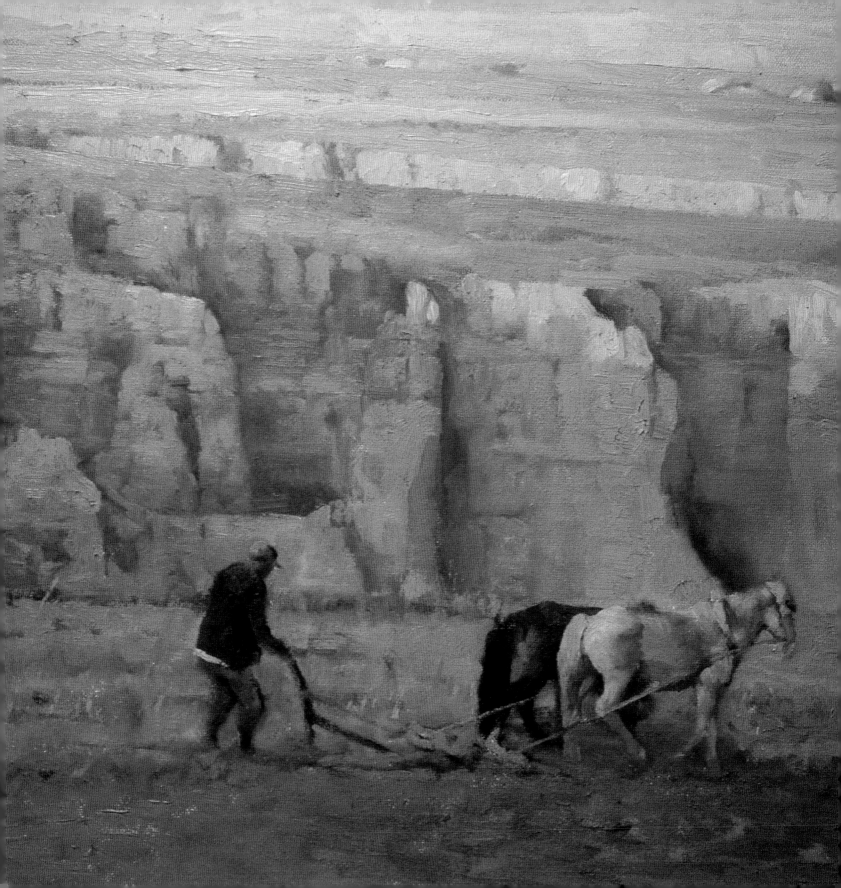

COLOR TEMPERATURE

THE WARM EARTH

24 × 20" (61 × 51 cm)

The Chinese words for "warm earth" liken the earth to the warmth of one's mother. This scene is from the land where I spent four years doing forced labor during my youth. My hard life there didn't change my love for this peaceful land. Warm-temperature colors not only show the sunset on the yellow clay; they also reveal my warm feeling.

WARM/COOL

Almost at the same time that we perceive a painting's tone of value, we feel its overall color. It may be a quiet study in blues, or a riot of reds. It may be so neutral that it's difficult to name the color, but somehow, we feel warmed or cooled by it. This quality of color is its temperature. We feel and react to a color's temperature as surely as we experience the temperature of our surroundings.

Color temperature has a wide range from hot to cold, just as values pitch from black to white. By the same logic as the last chapter, we use yin/yang here to understand colors by temperature. The principles are consistently analogous; everything we covered that applied to value also works with temperature. The yin/yang pair governing color temperature is cool/warm.

Color temperature helps set a mood that we feel directly, in much the same way as a passage of music can bypass the conscious mind and squeeze one's heart. Yang-temperature colors are associated with energy, excitement, activity, strength. Yin-temperature colors inspire feelings of serenity, loneliness, gentleness.

YANG: WARM COLORS

Colors that have yang temperature are red, orange, and yellow. Exuding a vibrant energy that resembles fire, sun, and light, these colors tend to come forward *visually. They feel active, positive, expansive.*

YIN: COOL COLORS

Colors that have yin temperature are green, blue, and purple. Showing a peaceful quietude that recalls the sky, ocean, and ice, these colors tend to recede *visually. They feel passive, negative, shrinking.*

START WITH A COLOR STUDY

A color study shows the painting's image without detail, as if viewed from a great distance.

If you walk into a large room and spot a painting quite far ahead on the wall—why would you be drawn to proceed right to it? Because of its color. Before you even know what the image depicts, you will feel "infected" by its warmth, energy, and joyous light—its color temperature. When you get closer and can read the image clearly, you will probably find that it fits with the feeling you have already experienced, the aura that drew you to the painting.

Always do a preliminary color study to plan a painting's mood and deep feeling. In this planning stage, several color sketches may be needed while searching and working out the best choice of tonalities to express the theme.

Keeping the final study nearby while doing the painting helps keep the intended color and mood in the final work.

Use whatever inexpensive materials you find convenient. I usually use canvas panels or gessoed masonite, ranging from $4 \times 6"$ to no more than $8 \times 10"$. If it is large enough that you are tempted to paint details, you are defeating the purpose of a color study!

COLOR TEMPERATURE STUDY

Warm temperatures are exaggerated in my color study to stress the underlying warm, yang tone of the painting.

MORNING WORK

24 × 20 (61 × 51 cm)

This painting is part of a series for my show "Portrait of a Colony: Views of Plimoth Plantation." These works, showing the daily life of those very early settlers who arrived on the Mayflower, were inspired by my feelings about the history of American immigration.

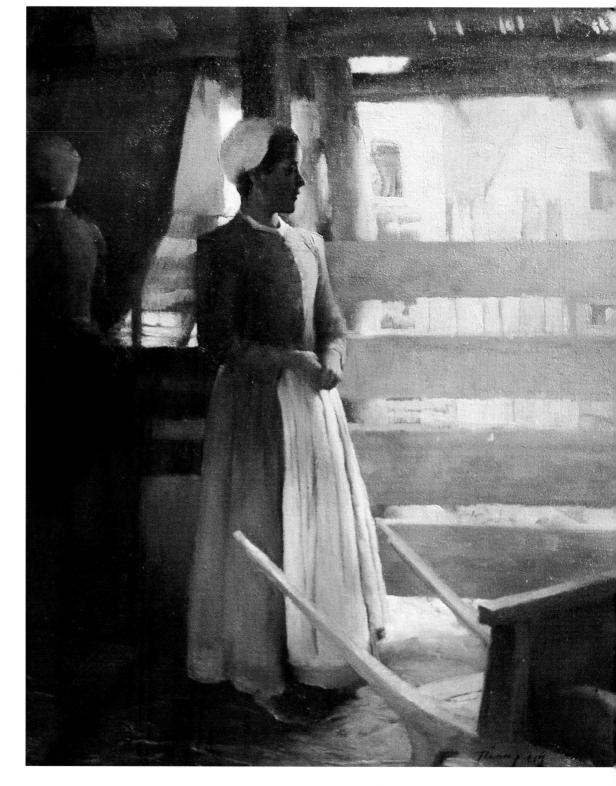

COLOR CREATES MOOD

Color casts the mood of a painting. These qualities—mood and deep feeling—are more essential to the artwork than any particulars of its story. You have the feeling of a painting before you even know what its subject is, what is happening on the canvas, what the details reveal.

COLOR TEMPERATURE STUDY

A broad range of warm to cool in both the yellows and the purples gives this study its vibrancy. The variety of color temperatures lends an exalted feeling to a simple scene.

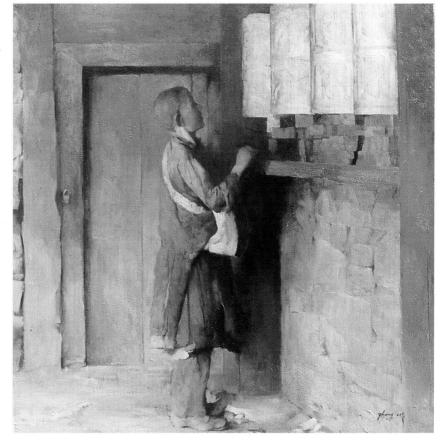

THE WISH

30 × 30" (76 × 76 cm)

A Tibetan youth's weathered cloak, the ancient temple door, and the peeling wall behind him are painted in purples of many different temperatures. On the right, the golden prayer wheels and mud wall are filled with a diversity of warmer and cooler yellows. The richness of this range of colors within a hue creates a scintillating effect that elevates the simplicity of the boy and the humble temple to a reverent, mysterious holiness.

31

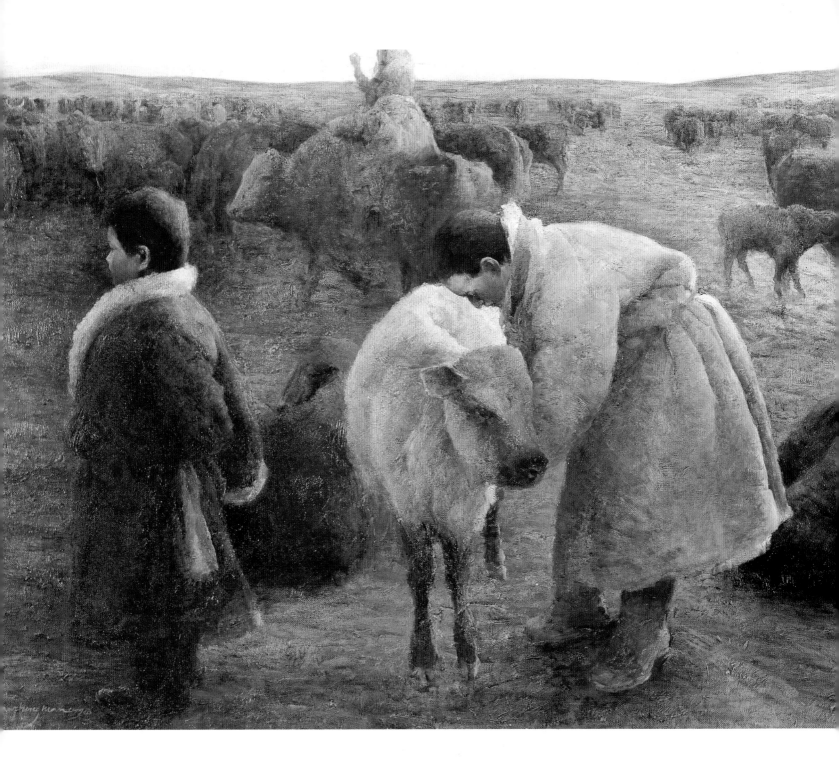

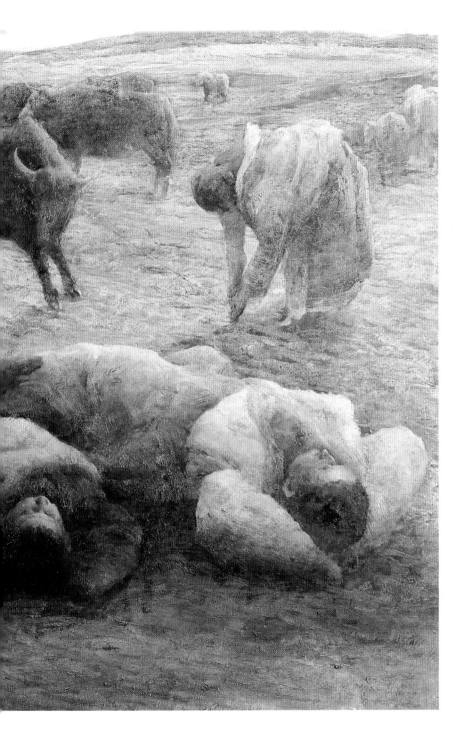

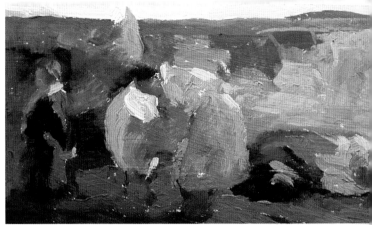

COLOR TEMPERATURE
STUDY

The quiet wistfulness one feels from the neutral, cool colors of this sketch is reinforced by the clear image of the finished painting.

CLOSE TO THE LAND
33 × 68" (84 × 173 cm)

A cold sunset on the high plains is the backdrop to a group of Tibetan youths. Set in a faraway corner of the world, this nostalgic scene of boys enjoying the peaceful solitude of their childhood requires cool colors: blues, mauves, and greens.

COLOR TEMPERATURE SCALES

An advantage of applying yin/yang theory to temperature is the enhanced ability to control minute differences in color. This subtle comprehension of temperature develops only when using yin/yang to compare colors within a hue.

Just as you can make a value scale of all the grays from black (yin) to white (yang), you can create a hue's temperature scale of the myriad tints between cold and hot. These nuances in color temperature are important tools in creating beauty and conveying emotion in oil painting.

Color temperature scales for the three primary colors—red, yellow, blue—are shown on these two pages. The pigments used in each scale are identified in the captions.

RED TEMPERATURE SCALE

Permanent magenta, cadmium red deep, and cadmium red light cover the spectrum of reds, which range from cold to hot. Permanent magenta is cooler than cadmium red deep because it contains more yin (blue) elements. Cadmium red light is warmer than cadmium red deep due to its greater number of yang (orange) elements.

YELLOW TEMPERATURE SCALE

Cadmium yellow deep, cadmium yellow light, and cinnabar light make up this hue group. Comparing these pigments, cadmium yellow deep is the warmest, owing to its larger quantity of yang (orange) elements. Cinnabar light is cooler because of its greater proportion of yin (green) elements. Cadmium yellow light is a true yellow.

BLUE TEMPERATURE SCALE

At first sight, these hues all appear to be cold. But once your eye adjusts, you can see that there are warmer and cooler temperature shades within the blue family. Blue violet is warmer than cobalt blue because of its additional yang (red) element. Pthalo turquoise blue is more yin (green), or colder, than the other blues.

THE COMPANIONS

40 × 30" (101 × 76 cm)

~

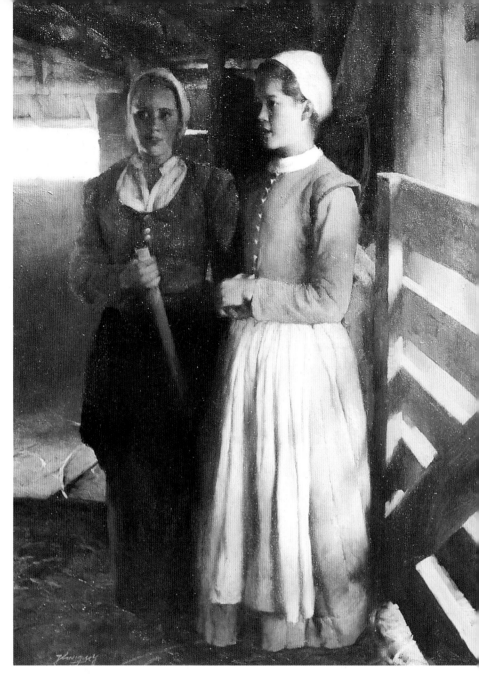

This entire painting is composed in cooler temperatures that allude to the serene life of these young pilgrim women. Yet, these yin colors have a relative change from warmer to cooler to show the space from the front to the rear. Compare the deep corner of the barn to the girl in the shadow and then to the girl in the foreground. The girl in front is painted in bluish tones that have been warmed up with orange. Note the sense of dramatic lighting and chiaroscuro—the modeling of subtle gradations of light and dark—and the depth created by controlled temperature differences. Remember the principle we stated earlier that yang (warmer) tones come forward and yin (cooler) tones recede?

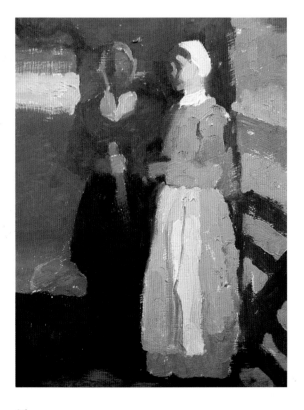

COLOR TEMPERATURE STUDY

~

The study reveals how the gray-blue tones are warmed with orange in areas that come forward or are lit.

SPRING ANGEL

30 × 24" (76 × 61 cm)

This high-keyed, dreamy painting is unusual because of how it shows solidity and weight in its forms. The largest areas are dominated by the white dress and cherry blossoms, and neither presented a dark shadow. How do you show form when any transition from light to dark is weak? By using temperature instead of value to create "lights" and "darks." As the planes of any of these lighter objects turn away from the light source, the color I used is more yin (cooler, or greener). Where the planes are washed in light, the color is more yang (warmer, or pinker). That way, the misty spring morning scene still has a classic quality.

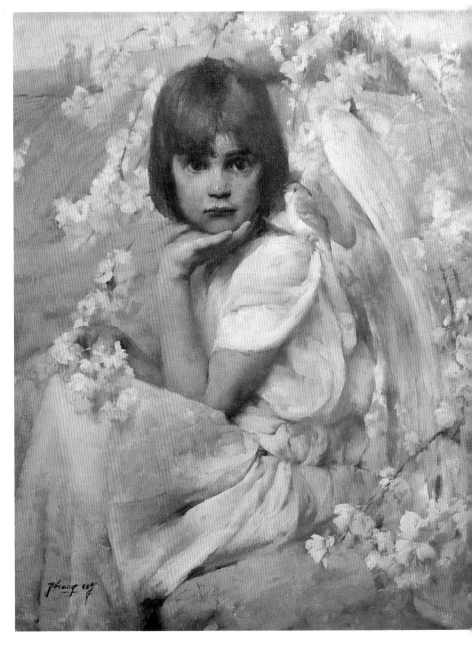

COLOR TEMPERATURE STUDY

A yang painting with a high key like this demanded temperature transition to create a sense of form and depth. The dark, cold yin pattern anchors the subject to the ground.

COLOR INTENSITY

LAST DREAM OF SUMMER

18 × 39" (46 × 99 cm)

The soft, subdued colors of this painting contribute to its warm, dreamy quality. The fading intensity of the late summer sun is alluded to with washed-out colors. You can feel the woman's skin being gently touched by warm sunlight and whispering breezes.

VIVID/QUIET

Most of us have had the experience—if not in painting, perhaps in trying to match clothing—of finding two colors in the same hue, value, and temperature that are still different. One hue may be incredibly vivid and the other quiet. This quality of color is known as intensity. A color high in concentration is bright and pure. Subdued tints of the same hue are less saturated with pigment. The yin/yang pair governing color intensity is soft/strong.

Continuing in the same line of discovery, we find that the logic of yin/yang applies to color intensity in much the same way that it applies to color temperature and value. Intensity can vary in degrees from bright to subdued. Strong (yang) color tends to come forward, while soft (yin) color recedes. Color intensity affects mood: vivid color is exciting; quiet tones connote peace.

Many painting phenomena are explained through an understanding of color intensity. What is neutral color? Why are some neutral color mixtures muddy and some chalky? What is the relationship between strong color and neutral color?

COMBINING PRIMARIES

In oil painting, color intensity weakens as each pigment is added to a mixture. The more you mix in, the more neutral, or gray, the color becomes.

Below and opposite are examples of such mixtures, based on the primary colors. (Secondary colors, referred to in the captions that follow, will be discussed further, along with tertiary colors, in our next chapter.)

RED INTENSITY SCALE

Combining primaries red and yellow results in orange (termed a secondary color). This mixed orange is weaker, or softer, than either the red or the yellow separately. Mixing primaries red and blue produces purple (a secondary color), which is also quieter than either of its components. The very neutral, yin mixture (at the center) is the result of combining red with green (its opposite secondary). This is the most "grayed," since it comes from three pigments (red, yellow, blue), while the others are a blend of two. Shorthand formulas for these mixtures are: red + yellow = soft orange; red + blue = soft purple; red + green = gray.

YELLOW INTENSITY SCALE

Primary yellow mixed with primary red results in soft orange (a secondary). Adding yellow to blue pigment yields a gentle green (a secondary). When yellow is added to purple, the resultant mixture is a rich neutral. Shorthand formulas: yellow + blue = soft green; yellow + red = soft orange; yellow + purple = gray.

BLUE INTENSITY SCALE

Primaries blue plus yellow become a quiet green. Combining blue with red pigment results in a grayed purple. The most grayed neutral is obtained by mixing blue with its opposite secondary, orange. Shorthand formulas: blue + yellow = soft green; blue + red = soft purple; blue+ orange = gray.

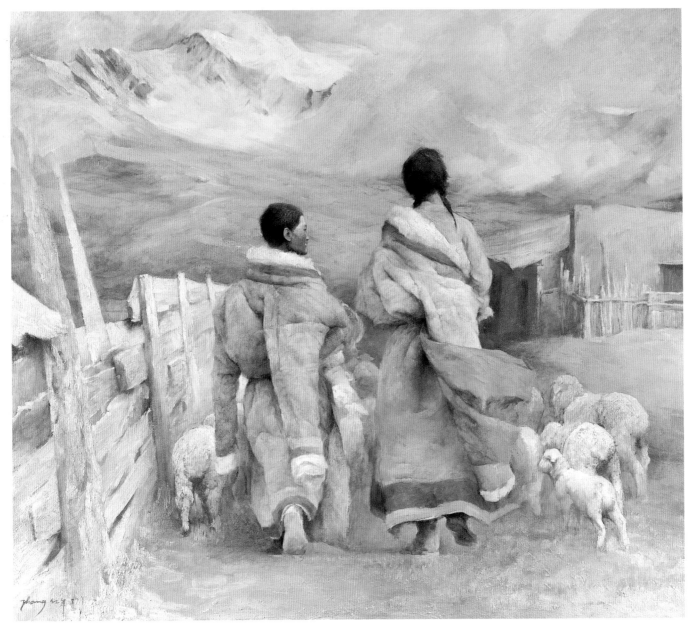

MORNING IN THE HIMALAYAS

36 × 40" (92 × 101 cm)

This painting shows a streak of bright blue in the girl's clothing, and orange in the boy's leather coat. Humming in the background are the muted blue tones of the snow-covered peaks, mist, and grasses, and the soft orange of the fence, earth, and building. These subdued colors are chromatic neutrals, since they were all created with various mixtures of the complements blue and orange.

CHROMATIC NEUTRALS

Generally, gray is a term used to describe value, but in this context, we use it to describe neutral color. These neutral "grays" are more lush than a black-and-white gray, and their sensitive tonalities are prized by most painters.

The beauty of these neutral tones arises from their chromatic components. Neutral tones carry the "DNA" of their parent colors. A neutral created with a blue and orange feels different from those made with red and green, or yellow and purple. They are different even if they exhibit the same degree of neutrality.

The most beautiful neutrals always keep some degree of identity by leaning slightly more to one of their parents. Avoid too many parent colors! If combining chromatically different neutrals with one another, the overmixed result is frequently a dead color.

FOOTSTEPS

24 × 28" (61 × 71 cm)

This painting shows a large field of neutral tones—the snow, jacket, and horse are all painted in chromatic neutral colors. These are so neutral that one is tempted to describe them as gray and white—yet, there is broken color within them. These neutrals were all created with various mixtures of the complements purple and yellow.

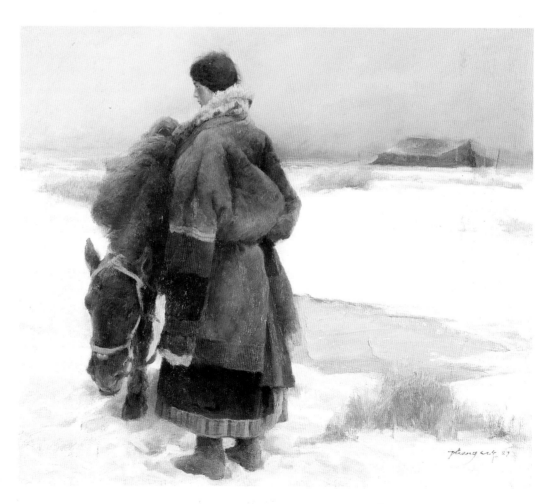

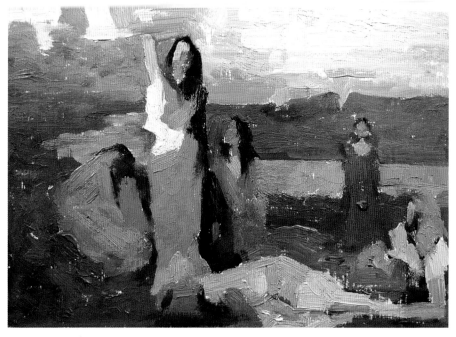

COLOR INTENSITY SCALE

The softer color in the landscape echoes and unifies the intense color of the leading figures. These neutral mixtures all contain some kind of red and green.

DAWN ON THE HUDSON

40 × 60" (101 × 153 cm)

Contrasts between soft and intense colors dominate this painting, yet see how their disparate tones support one another. In the context of intensity, the bold colors, both bright green and bright red, belong to the yang. The yin are the more neutral reds, pinks, and greens. The strong green on the robe of the leading figure is linked to the intense green of the foreground grasses, and is echoed in the much quieter green that appears on the distant shore. Similarly, the red-dressed girl stands out against the soft red tones in the ground and river behind her. These crimson tints also reverberate in the distant pink clouds.

EARTH TONES AND PASTELS

Paintings that are primarily composed in neutral, pastel, or earthy colors are very appealing, because their tones are much more subtle. All of the neutrals are understated colors created by mixing complementaries.

Why do we include pastel and earth colors in our discussion of neutrals? Because the earth tone is a warm, neutralized color, and the pastel is simply a color—whether strong or neutral—made lighter (and thus more neutral and cooler).

But colors made too chalky or muddy arise from a misunderstanding of neutral color. In the context of a painting, when only white is added to make a passage turn lighter, the resultant color appears chalky. It doesn't contain the neutralizing element: complementary color.

When a neutral mixture is "overcooked" or has lost its identity by being too much in the middle, it appears muddy. To avoid that look, do not use too many elements in your mixture.

Rich, earthy neutrals should be created with much more color than simply browns from the tube. All the color mixtures should involve some yang with some yin.

SUNFLOWERS

20 × 24" (51 × 61 cm)

The warm, earthy neutrals that dominate this painting are not made with brown pigment. Instead, they are mixtures of reds and greens. The red/green undertones are felt more keenly with the identifiable color of the girl's green dress and the reddish sunflower in the foreground.

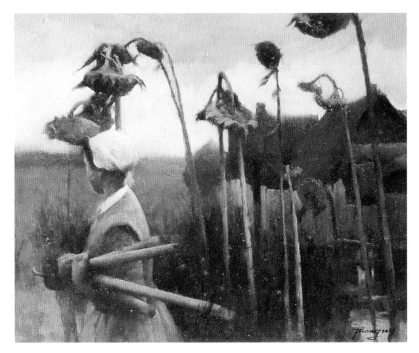

COLOR INTENSITY STUDY

This small study reveals the subtle red or green undertones of the mixtures.

POPPY

24 × 30" (61 × 76 cm)

A symphony of neutral pastel colors, this painting's mixtures are not simply purple and white or yellow and white—that would appear too chalky. Instead, all the lavender tones include some yellow, and all the light-yellow tones include some purple. The parent colors, yellow and purple, are suggested in the background, making all the colors come alive.

COLOR INTENSITY STUDY

All the tones, both lights and darks, involve yellows and purples in their mixtures. The white that was then added softens the color intensity as well as lightening it.

COLOR INTENSITY STUDY

~

Using the yin/yang of intensity produces color vibration and harmonies within unified colors. Here, the balance of intense and soft color not only reveals the focus and the background; it also implies the family connection.

THE COURTYARD

26 × 50" (66 × 127 cm)

~

This scene is like a stage filled with many actors in a setting of cooler and warmer "grays," which were actually mixed with oranges and blues—very neutral tones. The leading figures are dressed in vivid colors that are repeated in neutral versions in the background, figures, objects, and animals. The yin neutrals of the busy courtyard relate to the bright yang colors of the farmer and his wife, just as a chorus singing harmony relates to the soloists.

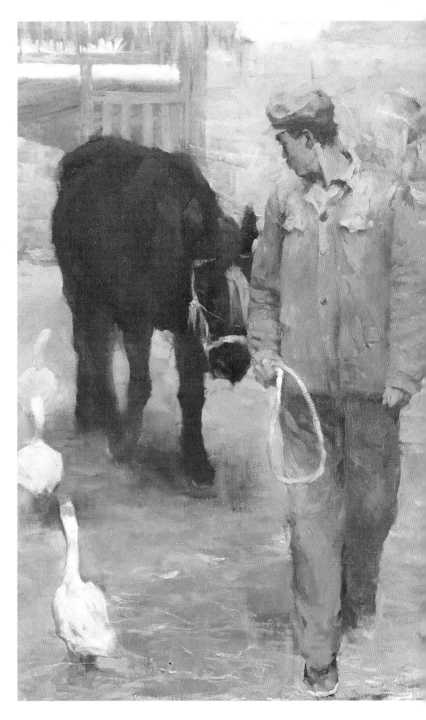

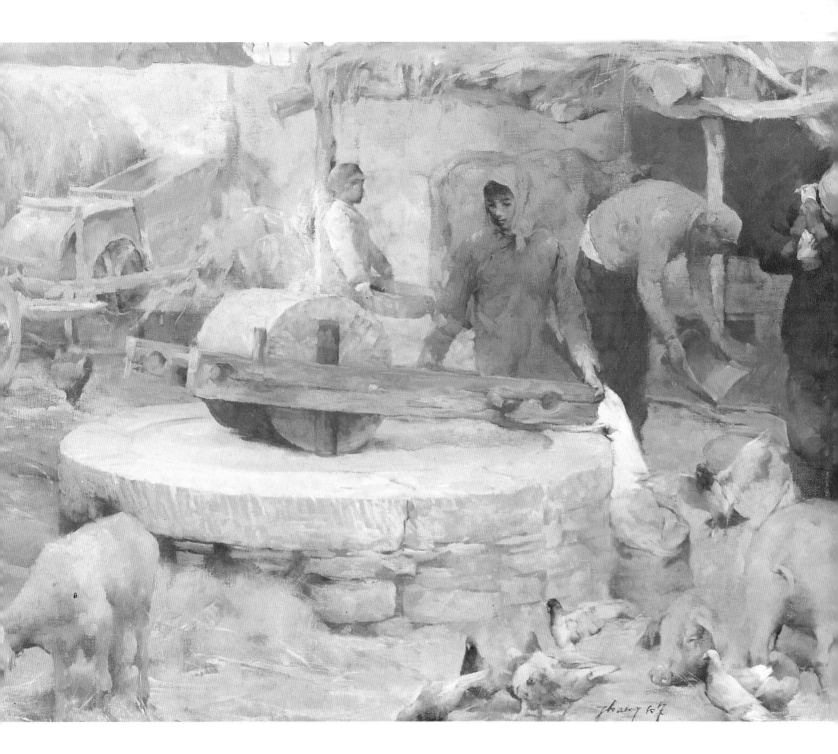

49

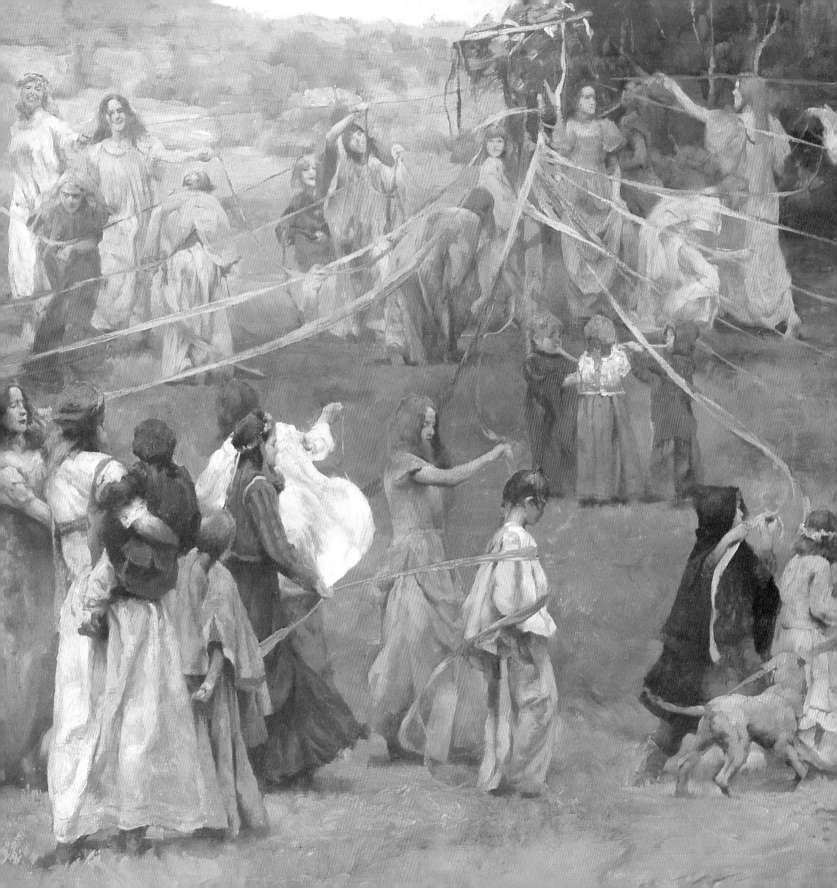

COMPLEMENTARY HUES

RITE OF SPRING (detail)

32 × 70" (81 × 178 cm)

Every year in Woodstock, there is a Renaissance Festival. The maypole dance is its highlight. The pageantry of it inspired this painting. In an abstract way of thinking, the painting resembles sheet music about the spring season. The red spots of color are musical notes arranged on a whirling ribbon staff, drawn against a green background. These red notes follow the light movement in a lilting rhythm, showing the hymn of youth, rebirth, and spring.

OPPOSITES ATTRACT

After value, temperature, and intensity, the next most dramatic element of contrast is complementary hues—pairs of colors that share no common elements and, when mixed, create a chromatically neutral "gray."

For those of you who are familiar with color wheels, complementaries are always shown directly opposite each other—that is, each primary (red, yellow, blue) is opposite a secondary (green, purple, orange). Across from red is green; across from yellow is purple; across from blue is orange.

Of course, the tertiary colors have their direct complements as well, such as blue-green with red-orange. A tertiary color is produced by mixing a secondary with an adjacent primary. However, since we are considering entire color families, our discussion of each primary and its opposite secondary will encompass the tertiaries as well. These complementary color families are the yin/yang pairs governing complementary color. The yin/yang pairs are purple/yellow, blue/orange, and green/red.

THREE YIN/YANG PALETTES

An understanding of the yin/yang of complementary colors is built on grasping the information presented in the previous three chapters. The yin/yang principles for the elements already discussed correlate directly to complementary color. For example, two complementary colors support each other when side by side and weaken each other when mixed. Remember how this is true for colors of opposing value, temperature, and intensity?

The most revolutionary idea of our yin/yang approach to painting is to base our palette on these principles. Instead of a more traditional palette, we limit ours to the families of the two complementary colors we feel are best suited to the subject being painted, and white and black. Of course, this means that we have three different palettes, one for each of the yin/yang pairs.

In the three sections following, we discuss each of our carefully selected complementary color palettes. All the pigments listed are Old Holland brand, unless stated otherwise. You can use any brand you'd prefer, but be careful to visually check that the color appears similar. There are often differences in pigment among manufacturers. (See "Materials," page 141.) You can add any "favorite" colors not on our list, as long as you determine which palette and where they lie in relation to the other palette colors.

In our purple/yellow palette, the yellow (yang) family side is made up of cadmium yellow deep extra, cadmium yellow, and cinnabar green light extra. These are the intense yellows: one warm, one true, and one cool. Along the bottom right are raw sienna deep, and raw umber, the softer yellows. On the purple (yin) family side from the top down are magenta, bright violet, and blue violet, the intense purples: one warm, one true, and one cool. Along the bottom on the left is a softer purple, caput mortuum violet (also known as Mars violet). On the yang side at the top is titanium white. Ivory black is on the lower corner on the yin side. On the yang side, yellow ochre light could be added to the neutral yellows at the bottom.

PURPLE/YELLOW MIXTURES

From the mixtures in the center, you can see how complementary colors vibrate next to each other, and become more quiet when mixed. There is an incredible range for different values, temperatures, and intensities to the mixtures one can make, since each side (yin or yang) includes a wide array of pigments.

53

SHARED DREAMS

40 × 40" (101 × 101 cm)

❧

Purples play the role of the pyramid-shaped dark pattern in this painting, yet ,there is a wide range of tonalities within these purples. Their relationships among themselves add richness and drama. On the left, the girl's costume is cooler and darker; the central figure's dress is warmer and brighter; and the reclining figure's skirt is warmer and softer. The floor and the girls' legs are very neutral, yet dark; this passage contains more raw umber mixed into the bright violet. On the background wall hangs a silvery mirror. Its cold, crystal color was achieved by highly neutralizing cinnabar green light extra with titanium white, ivory black, and blue violet. In order to keep the painting in a cold tone, the girl's bare back was pitched toward a cooler, greenish yellow.

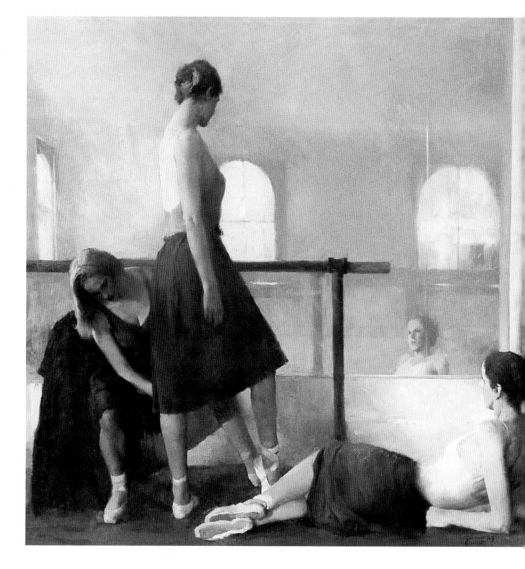

COLOR STUDY

❧

This light painting has a featured yin pattern that is dark and tinged with variegated purples. The yang pattern is suffused with cold yellows.

54

WOODLAND ANGEL

24 × 36" (61 × 92 cm)

〜

Another purple/yellow painting, this one is much warmer in tone than the previous example. The light movement from the daffodils and dress to the arm, face, wing, and sky is a serenade of yellows: some brighter, some softer, some lighter, some darker, some warmer, and some cooler. As counterpoint, the rock, pond, and background woods are composed in purples. The light/dark pattern is strengthened by the yin/yang of yellow in the light against purple in the dark. Yet, this pattern does not feel too obvious or simple, since it is hiding in a rich, realistic range of tones. These tones harmoniously unify the painting by having some amount of a purple in every yellow mixture, and some amount of a yellow in every purple.

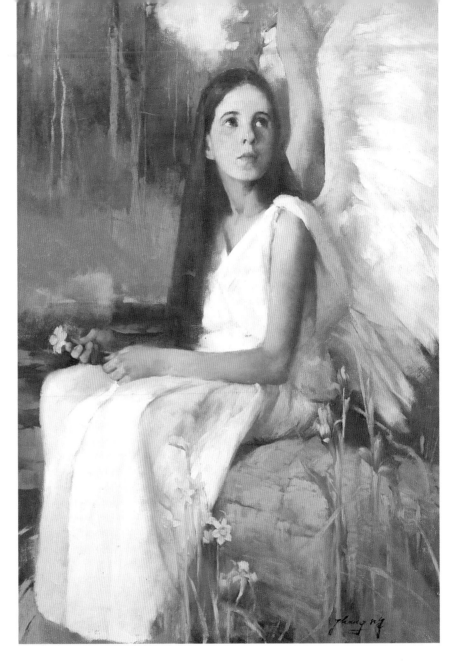

COLOR STUDY

〜

We see in this study that the dark pattern is carried by the purples, and the smaller, light pattern is the domain of the yellows.

BLUE/ORANGE PALETTE

On the orange (yang) side from the bottom up are cadmium red scarlet, cadmium orange, and cadmium yellow deep extra. These are the intense oranges: one warm, one true, and one cool. Along the bottom on the right is burnt sienna, a softer orange. On the blue (yin) side from the top down are blue violet, cobalt blue, and Rembrandt's phthalo turquoise blue. These are the intense blues: one warm, one true, and one cool. Along the bottom left is indigo, a softer blue. In the lower corner on the yin side is ivory black and on the top of the yang side is titanium white.

BLUE/ORANGE MIXTURES

The complementary colors of blue and orange vibrate when next to each other, and are muted when mixed. There is a wide range of possible mixtures one can make, since each side (yin or yang) includes a broad array of pigments. Each "orange" can mix with any "blue," can lean more to either orange or blue, and can have any degree of white and/or black added.

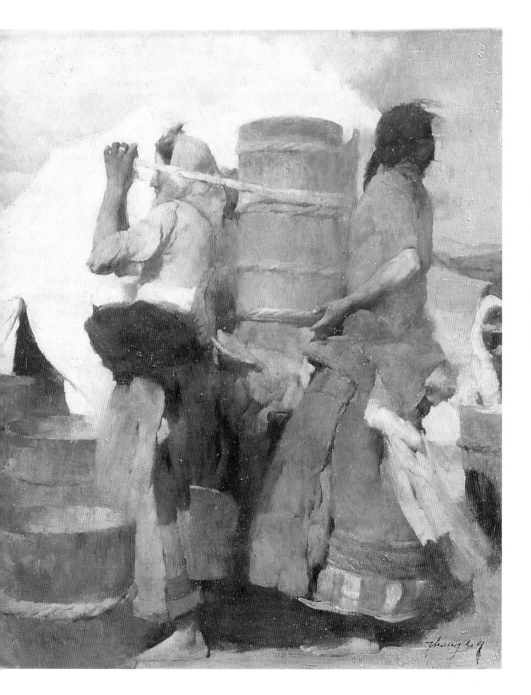

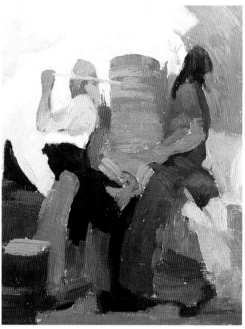

COLOR STUDY

This study's bright colors seem still more vivid because the complements are in juxtaposition. The blue areas feel bluer next to orange, and vice versa. Orange is the leading color in the larger yang pattern, and blue dominates the smaller yin pattern.

WORKING TOGETHER

30 × 24" (76 × 61 cm)

The clean, bright-blue sky in the Tibetan highlands provided a backdrop for this scene. The intensity of that blue became the motif for selecting a blue/orange palette. The bluer areas of the painting are linked together to form a colder, darker, V-shaped (yin) pattern. This "V" makes a strong mark against the orange (yang) pattern; its uplifting shape inspires a heroic feeling.

SPRING THAW

29 × 35" (74 × 89 cm)

ᕦ

The color in this painting is vastly different from the previous one, even though it was created from the same blue/orange palette. Working Together (page 57) sings with brilliant color, while Spring Thaw *whispers in subdued tones; it has a lighter, warmer yang pattern of movement. The yin backdrop to this yang pattern is not especially dark. It is yin mainly for being cooler and more neutral. The blue in the girl's jacket is found again in very neutral tones in the tree, sheep, and village behind her. These are all rather cold, soft blues that dominate a large portion of the canvas. Gently contrasting this are the neutral orange tones of the sky, the girl's headdress, face, the road, and basket. These light, warm colors are linked to form a melting snow pattern that gently ebbs and flows from the upper-left corner to the lower right.*

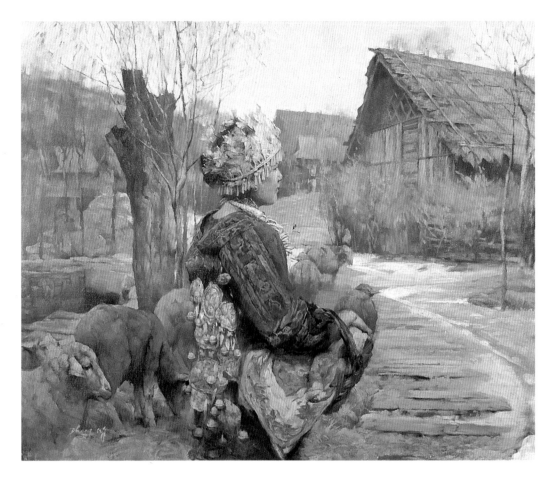

COLOR STUDY

ᕦ

The cool neutrals and blues form the large yin pattern, while the lighter, warmer neutrals and oranges form a pattern of yang movement. The study exaggerates these patterns and the underlying blue versus orange color.

GREEN/RED PALETTE

On the red (yang) side from the top down are cadmium red scarlet, cadmium red deep, and magenta. These are the intense reds: one warm, one true, and one cool. Along the bottom right are Venetian red and burnt sienna—both softer reds. On the green (yin) side from the top down are cinnabar green light extra, bright green, and Rembrandt's phthalo turquoise blue. These are the intense greens: one warm, one true, and one cool. Along the bottom left is green earth, a softer green. Ivory black is in the lower corner on the yin side; on the yang side at the top is titanium white. Raw umber could be added to the neutral greens at the bottom.

GREEN/RED MIXTURES

Green and red feel more intense when next to each other, and become quiet when combined. The range of potential color mixtures from this palette is immense, since there is a broad array of pigments on each side (yin or yang). Each "red" can mix with any "green," can lean more to either red or green, and can have any degree of white and/or black added.

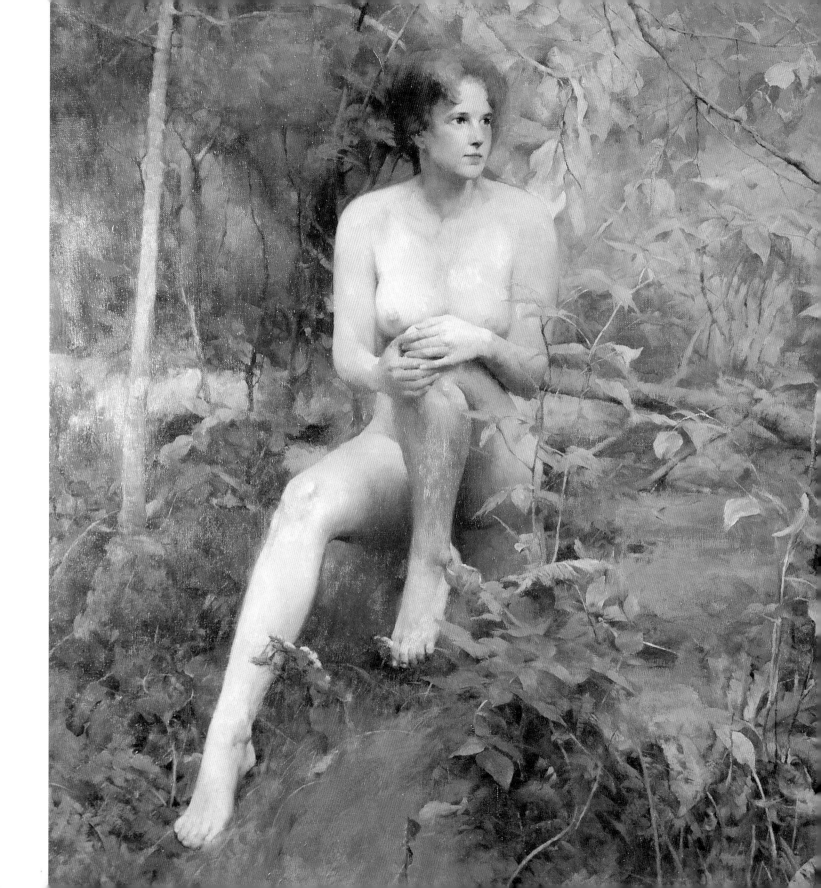

COLOR STUDY

᠁

The woman and sunlit leaves form a neutral, red, yang pattern. Her fair skin vibrates with the high-key, neutralized reddish and greenish tones.

WOODSTOCK SUMMER

54 × 74" (137 × 188 cm)

᠁

As you must by now see, the green areas in this work are unified into a larger, yin pattern. The sunlight dazzling through the leaves and the woman's hair and skin are softer red tones that lyrically rise and float across the canvas. An important element in this work, contributing to the naturalistic, atmospheric effect, is that each pattern contains areas that echo the other. The large section of deep green on the left is broken by a small, jagged area of dark-red neutrals. The backlit red pattern on the right is broken by slivers of light green. To enhance the realism of the form, the highlight on the woman's shoulder is another level of yin/yang contrasts. It is interpreted as a very high-keyed greenish neutral, in contrast to the pale reddish neutrals of her fair skin.

61

CREATING FORM

A major dilemma in painting is how to achieve form without sacrificing color. Some artists create great form by relying heavily on earth colors ("soy sauce" color to Chinese artists). Others who are colorists create paintings with loosely stated form. The challenge of achieving a high standard for both form and color is more easily met using the complementary color palette and yin/yang approach.

We use color to model a form. In a monochromatic painting, you would mix varying amounts of black and white to show the progressive change in light around an object. As you've learned, in yin/yang painting one color is assigned to the yin pattern and the other to the yang. To create a strong, colorful sense of form, we assign the yin color to the shadows and the yang to the light. We vary our mixtures between yang and yin to show the progressive change in light around an object. Using only value and temperature is not as powerful as using opposite colors. Look at the paintings in the book, and you will see this principle in action.

Complementary color palettes lead to paintings with strong color and beautifully harmonious, lush neutrals. By including the full spectrum of color in each family, the range of color mixtures is infinite. By limiting the palette to two families, the color mixtures are related and naturally create an atmospheric effect.

COLOR STUDY

This color study shows the underlying pattern. Warm, dark-red yin tones predominate, with light-green yang tones carrying the movement. This movement starts with the light-green background behind the seated woman, swings down to her lap, then across to the basket, up to the man's sleeve, and back to behind the woman. To strengthen the circularity of this movement, I exaggerated the light on the man's outer sleeve, and muted the light on his shoulders.

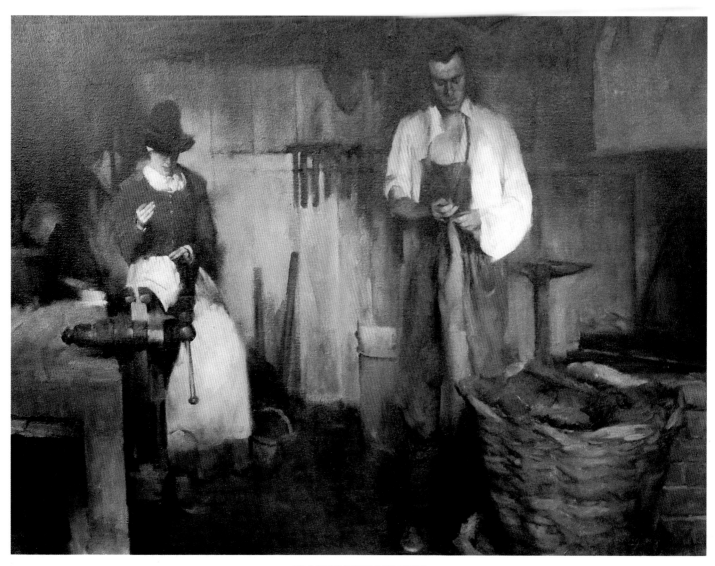

BLACKSMITH'S FAMILY

30 × 40" (76 × 101 cm)

The circular yang pattern in Blacksmith's Family *suggests the unity of the Early American working family. This area appears dimly lit by virtue of its neutral light-green tones. The dark, yin pattern surrounding this is colored in deep sonorous reds. This painting illustrates a peculiarity of the green/red palette: its yin/yang colors can be flipped. Sometimes the dark pattern lends itself more to red, while the light pattern feels more green. The same device of contrasting the highlight color against the light tone to enhance the form can be seen here; notice the light pink highlight on the pale-green clothing.*

TEXTURE

GOING TO SCHOOL
23 × 27" (59 × 69 cm)

*Texture plays an important role in this paint-
ing. The modeling of the children's clothing is
done not only by value and color, but also
with texture. The thick "yang" paint on the
sides facing the light is supported by the thin
"yin" application of paint in darker, shadowy
areas. Distance is implied through the
yin/yang of the thickly textured subject
against the thin texture of the horizon. The
illusion of reality is more powerful because of
its texture.*

65

CONSISTENCY VARIATIONS

Oil paint is a unique material that can create beauty other materials cannot. One such beauty is its texture, evident in two different ways. The application can range from thick (impasto) to thin, and the consistency can extend from opaque to transparent.

Paint application varying from thick to thin creates a more energetic canvas surface. Its sculptural effect can increase the illusion of form. The balance of opaque and transparent paint enhances the sense of distance. These opposites, thick/thin and opaque/transparent, are our yin/yang elements governing texture.

PREPARING FOR WINTER

40 × 30" (101 × 76 cm)

In Hong Yuan County in Tibet, the women work hard preparing provisions for winter. I was inspired by the varied textures of the hay, the adobe wall, and the women's clothing. Oil paint lends itself to depicting believable textures of objects, and to creating a beautiful surface, showing rich paint quality.

DETAIL

Transparent paint for the dark window creates a mysterious void alongside the thick, opaque paint of the sunlit adobe wall. Thick paint in the woman's headscarf firmly establishes the space between her and the window.

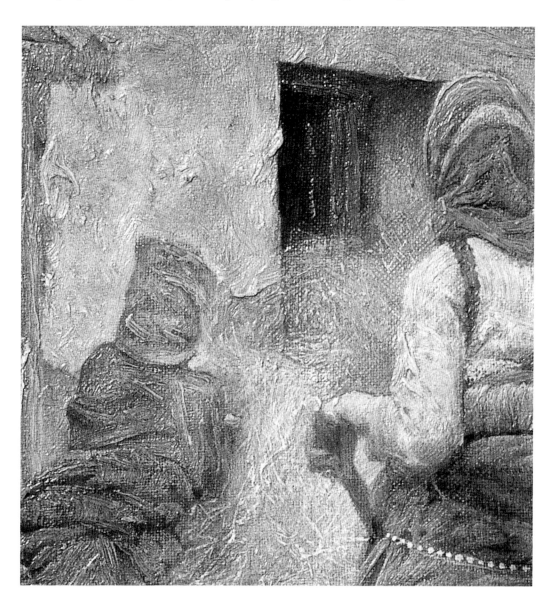

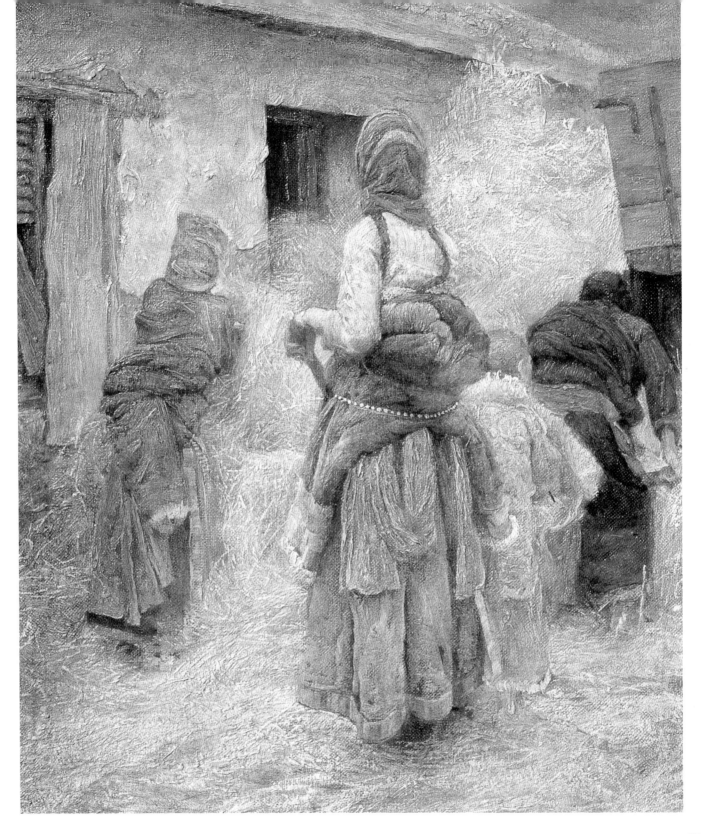

THICK/THIN; OPAQUE/ TRANSPARENT

To create thick texture, use a heavily charged brush. Put the paint down and leave it alone; let the brush leave its own special mark. When using texture to describe form, use thinner and more transparent paint to create the dark, cool shadows. Where dark shadows turn lighter, try introducing a small amount of warm color to the shadow mixture, instead of white. Resort to adding white (sparingly) only where the warm color doesn't lighten enough. Opaque, thick, roughly textured paint will lift the warmer, brighter lights.

 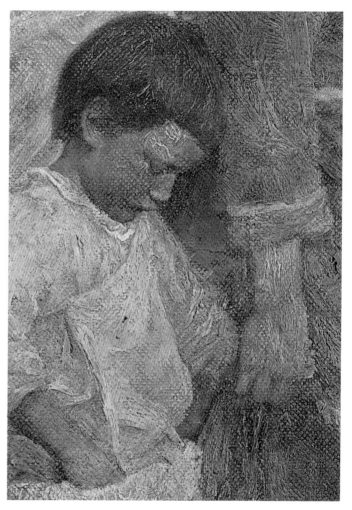

DETAILS

These details of the painting on the opposite page reveal the visual touch of its different textures: leather, cloth, and weathered wood.

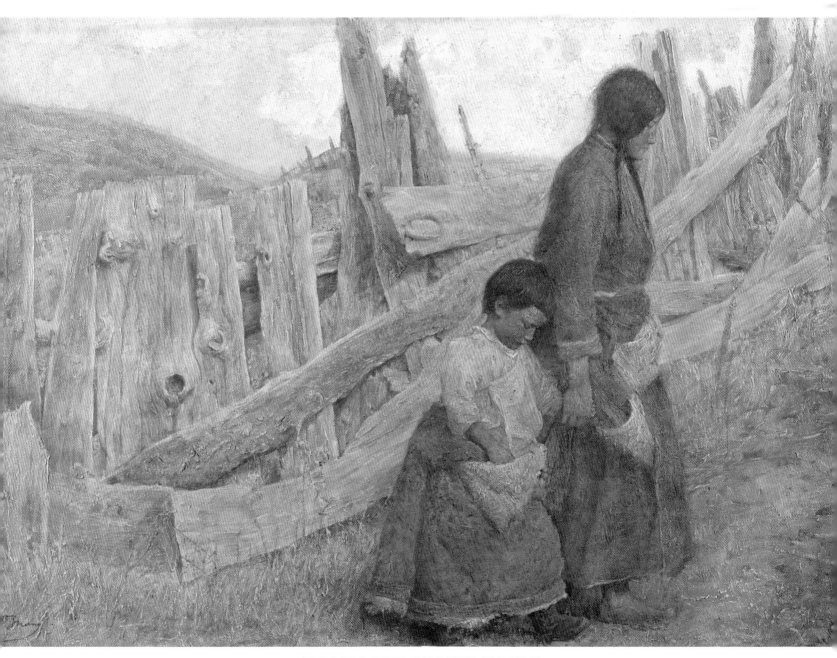

THE LONG, LONG THOUGHTS OF YOUTH

25 × 36" (64 × 92 cm)

The heavy textures of this painting not only impart a realistic appearance to objects; they also give the entire surface a deep, aged quality. The up/down of the thick/thin surface creates a visual touch charged with stored energy. This kind of surface texture often suggests a treasured, timeless feeling.

GLAZED FINISH

After all the paint has dried, use transparent color in a glaze application to further enhance textural forms. One real joy of oil painting is using transparency to create gemlike layers of color. Light passing through the transparent layers illuminates the more opaque color beneath. These glazes add an air of mystery and beauty to a painting.

DETAILS

These details of The Floral Wreath *reveal both thin and thick brush-work. Note how glaze application puddles in the valleys, made by brush bristles, further enhances the sculptural effect.*

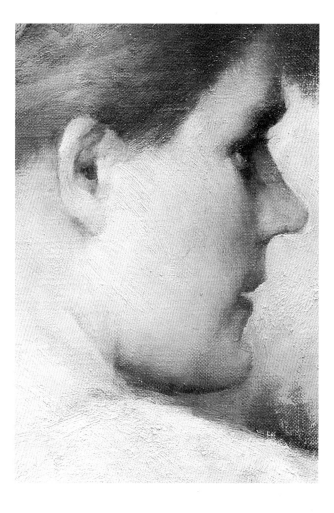

THE FLORAL WREATH

24 × 20" (61 × 51 cm)

Painted in a classical style, this painting exhibits a wide variety of paint quality, from thick to thin and from opaque to transparent.

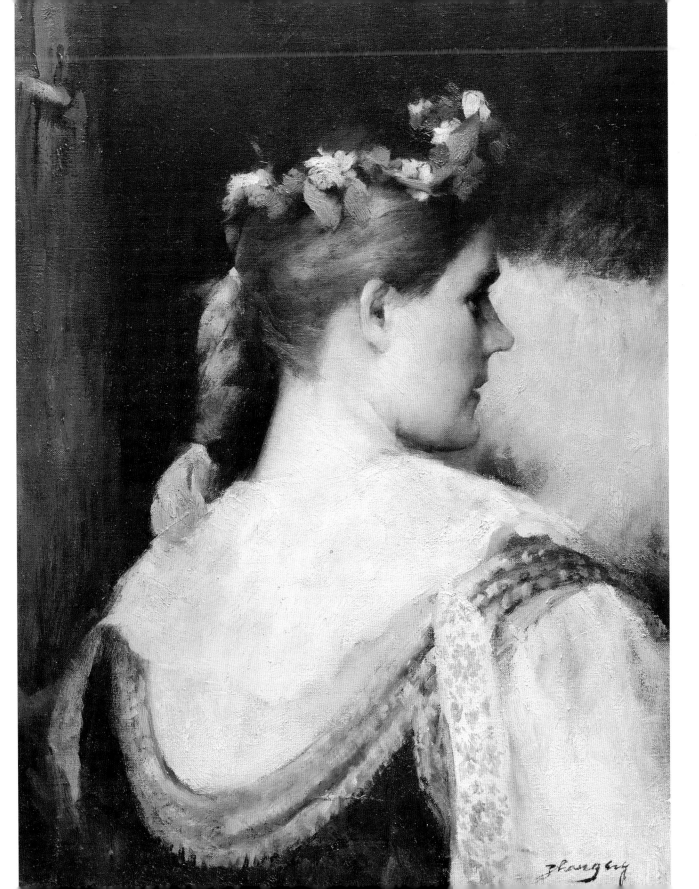

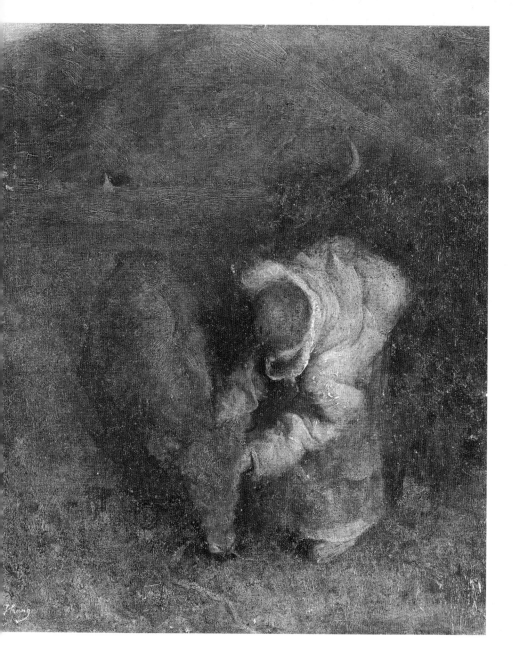

The stormy atmosphere in this scene was created with many layers of transparent dark glazes. This veil of glazes covers the yak, ground, and some of the figure's clothing, pushing them into the dark night. The opaque, strongly textured paint on the woman's clothing forms the light, yang pattern.

DETAIL

This detail shows how glazes enhance the yang texture of heavy brushwork by puddling in the crevices.

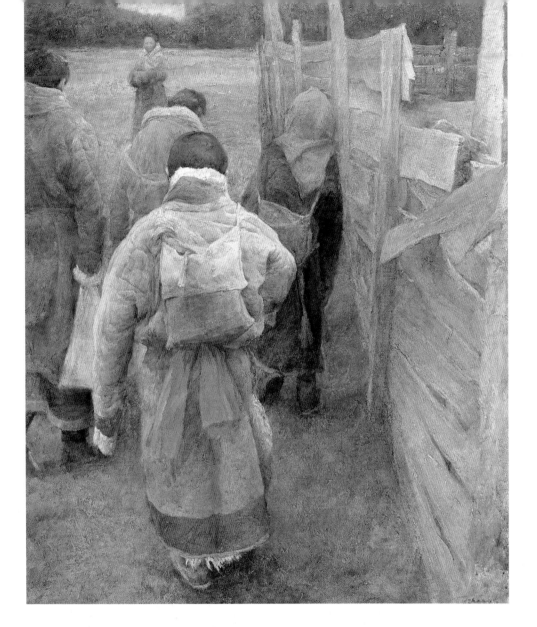

MORNING

30 × 24" (76 × 61 cm)

This painting of a scene in a Tibetan village exhibits a variety of brushstrokes. Confident, short strokes, randomly changing direction, impart a visual touch that describes the nap and folds of the heavy sheepskin. Loose, patting brushstrokes make up the short scrubby grass, while the fence is painted with long, sinewy strokes to show the lumber's rough grain.

DETAILS

Brushwork is the single most important tool for showing texture. Soft, squared, sponged, long, and smooth brushstrokes are evident in these details from Morning.

BRUSHWORK VARIATIONS

The quality of rich brushwork can also be explained using the yin/yang approach. First, there is brushstroke direction—up/down, left/right, and so forth. Second, there is its length, or the yin/yang of long/short. Third is speed—that is, fast/slow. Then there is edge quality, or the side of a brushstroke's clarity, which can vary from sharp to blurred. All these different styles of brushwork create the *chi*—another Chinese concept—the inner energy, or life force, of painting.

MAN'S PROFILE

14 × 11" (36 × 28 cm)

Energetic brushwork is featured in this work. Different directions of brushstrokes not only strengthen the form of the head, but also lend more intensity to the man's facial expression.

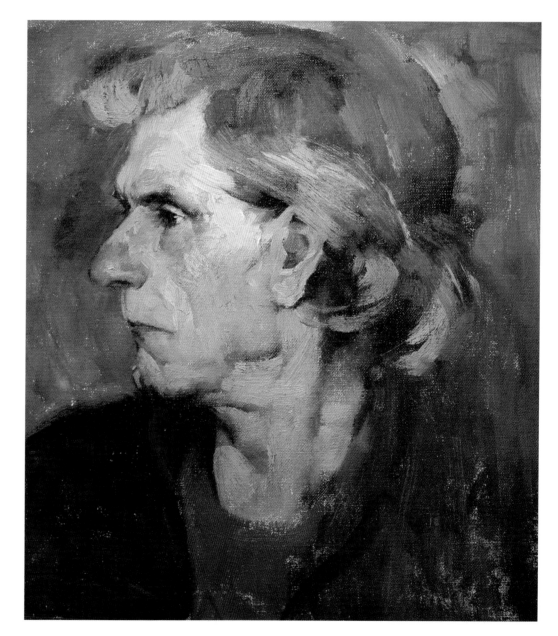

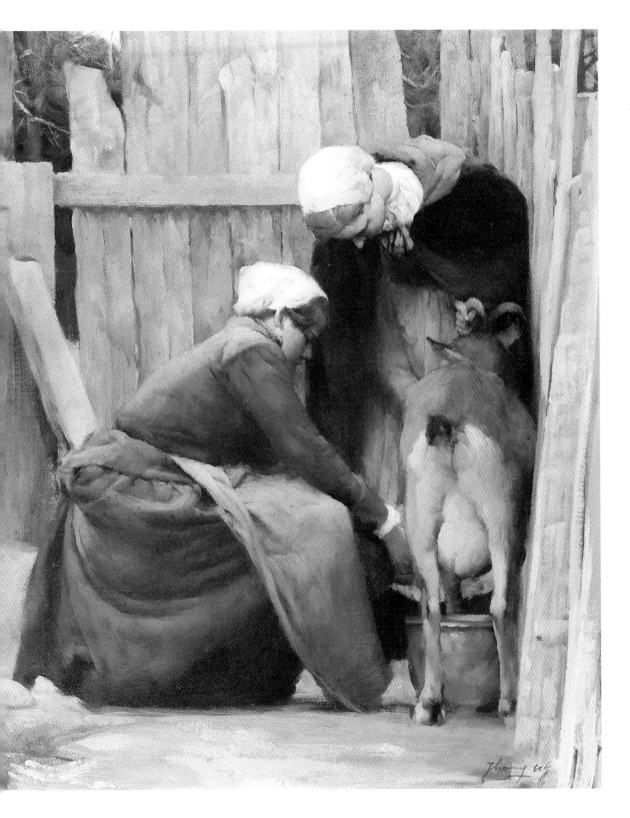

THE DAIRY GOAT
30 × 40" (76 × 101 cm)

Here, a beautiful rhythm is created by the yin/yang of short brushwork used in the background fence against the long, flowing brushwork of the women's clothing.

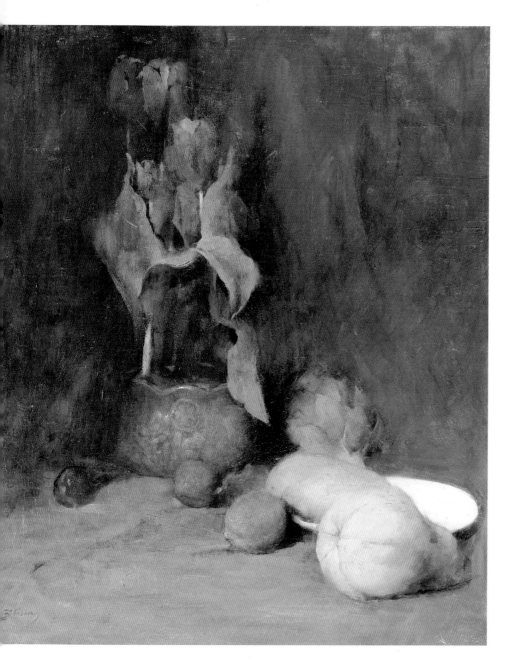

DETAIL

Fast/slow brushstrokes suggest both movement and stillness.

STILL LIFE WITH TULIPS

24 × 20" (61 × 51 cm)

High-speed brushwork was used on the leaves in this still life to contrast with the careful, slow brushwork of the container. These brushstrokes dance with each other—one is moving and the other is still.

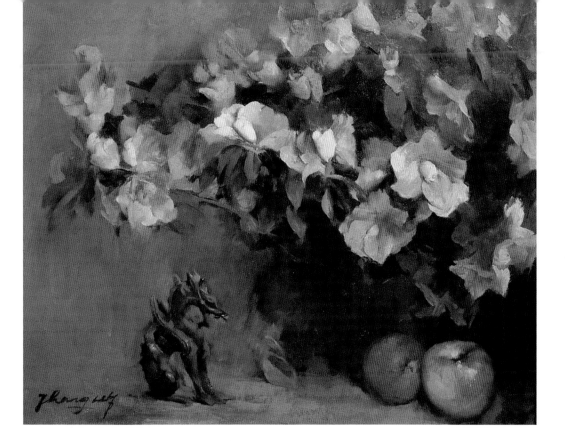

AZALEAS

20 × 24" (51 × 61 cm)

❧

Talking about dancing brushstrokes, Azaleas is a ballet! Every degree of clarity from sharp to blurred is evident in its brushstroke edges. Life is given to each petal, almost as if they are trembling in the air.

DETAIL

❧

The yin/yang of soft versus blurred edges is illustrated in this detail.

STILL LIFE PAINTING

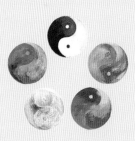

THE TANG HORSE

16 × 20" (41 × 51 cm)

One beauty of still life painting is the exceptional attention given to form. The roundness of a peach, the crisp, thin edge of a leaf, the fullness of a flower all invite one's eye to touch.

FOCUS ON FAMILIAR OBJECTS

The beauty of a still life painting is in its quiet focus on objects familiar to us. Sometimes these are treasured antiques or personal belongings, sometimes they are flowers and produce picked from a garden. Whatever the objects are, their arrangement, color, and lighting are fundamental to the painting's beauty.

Still life painting is the way I first present my color theory to students in the classroom. I select objects and cloths for their color relationships, and arrange them in a way that facilitates learning my ideas about composition and color.

I have a clear concept for the value, temperature, and intensity of each setup. For instance, one grouping may be arranged in cold, dark color. Another may be based on warm, light tones. Each setup has an overall color harmony that casts a mood consistent with the connotation of the objects.

Still life is one of the best venues available for mastering the craft of oil painting. Only items to be depicted are put in the setup. Since still life is usually done indoors, lighting can be controlled. More time is possible for understanding and modeling the forms because, of course, the setup will hold its pose far longer than a living model. Selections of different textured objects, such as glass, copper, or velvet, demand a higher skill with the brush and color mixtures.

The following demonstrations put into action the various yin/yang principles we've reviewed in earlier pages.

THE HALF-FULL GLASS

16 × 20" (41 × 51 cm)

This arrangement of fruits was striking for its interesting variety of shapes. Their shapes are emphasized by using darks to suppot lights and vice versa, and by linking the less-important dark areas of the vase with the shadow beneath the bowl. The curving highlights in the glass echo some of these shapes.

FLOWERS, FRUIT, CLOTH

Preliminaries

Before starting a painting, I spend a little time designing its value pattern and painting a color study. The value pattern is often just a thumbnail sketch to help me understand the balance of light/dark and its movement. The color study gets more attention, not to detail, but to catching my fresh feeling of the color. First impressions need to be caught quickly. Unfortunately, the more we examine a setting, the more we lose that rush of color felt initially. The color study stays beside my easel to remind me of that first rush of color.

VALUE STUDY

COLOR STUDY

STEP 1

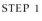

I freely put down my colors for the dark (yin) pattern. These mixtures all lean to purple, the yin color, yet they vary in temperature, value, and intensity. I am not thinking about darks to show form—rather, only to create movement. My first step usually appears this abstract.

STEP 2

Now I cover the rest of the canvas with the yang color mixtures appropriate for each item. I proceed from the darker middle values to the lightest, adjusting the color mixtures to reflect my constant search for warmer, cooler, brighter, softer. The neutral background is ever so slightly more yellow, keeping it in the yang pattern. Now, before proceeding to the next step, I remove any excess paint by gently scraping those areas with a palette knife.

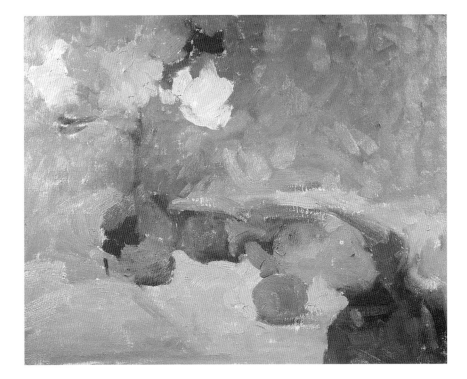

DETAILS

These details reveal the richness of color for the flowers, fruit, and cloth. Comparing similar colors makes it easier to find and record the small, yet sensitive, differences. I did this quickly and with an abundance of paint. Once the canvas is covered, I'm in my wonderland.

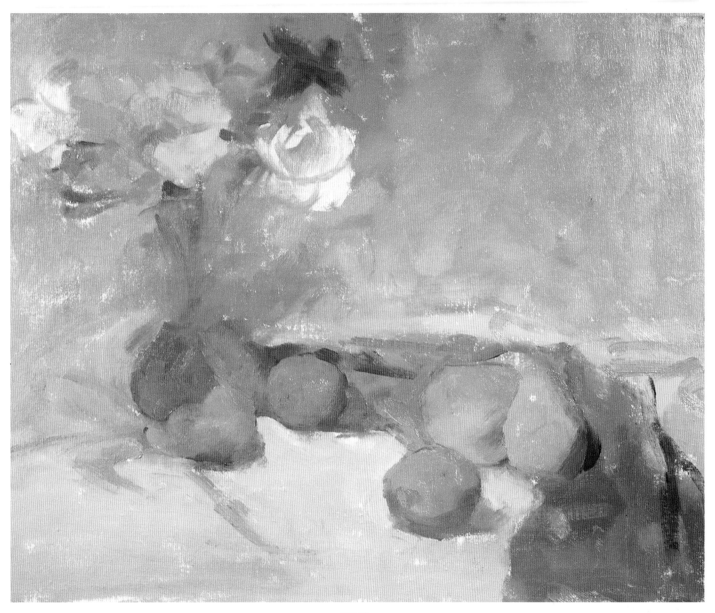

STEP 3

I redefine the shadows, paying careful attention to their shapes and tones. By comparing shadow tones with each other, elegant differences will be noticed. In this step I use thinner application of paint, sometimes preferring a softer brush. Form is my focus as I repaint shadows and connect cast shadows, one by one.

DETILS

These details show the development of shadows to create form. All the shadows were created from some kind of yellowish purple mixture. They may not seem purple. Some colors appear green or even orange. Yet, they all have some blood relationship to one another.

DETAILS

These details show how the brushwork speed and texture give life as well as form to the flowers and fruit. A few delicate, crisp edges imply the blossoms' fragility. Short, square brushstrokes give weight to the fruit. Strong yin/yang brings objects closer, and subtle yin/yang pushes them back.

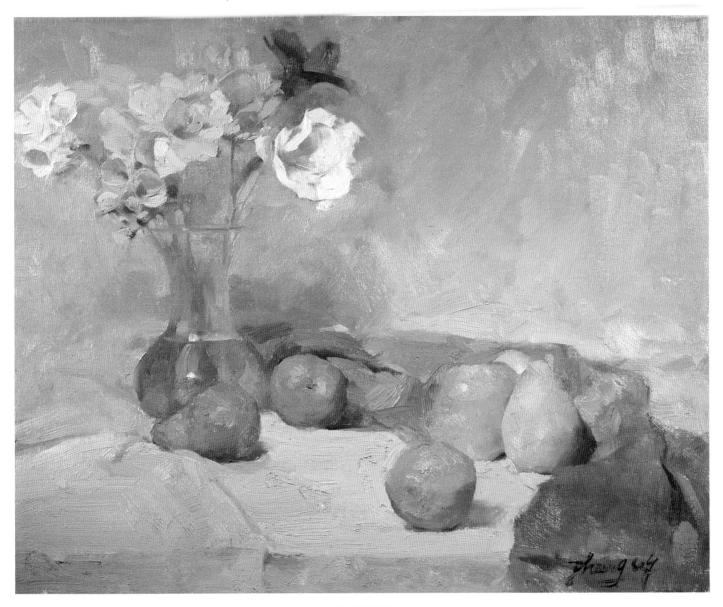

SERENADE

16 × 20" (41 × 51 cm)

Now it's showtime! A lot of brushwork is required to create a sense of form. When you work this step, at least your previous step should still be wet. This way, the dark pattern and shadow help create new color in transition areas. Pushing the brush harder or lighter creates different mixing effects. Some edges become hard, some soft. Thicker paint adds to the yang.

VARIED TEXTURES

STEP 1

This setup is characterized by cooler colors, so I chose a blue/orange palette. Painting the dark pattern first, I swiftly cover that area with bluish mixtures. Darker, cold blues for the background on the left mingle with yellow-orange color to suggest the foliage. Warmer, more intense blues are used in the foreground cloth and mug. Most of the dark pattern is painted in neutral blue tones created by mixing blues with oranges.

Preliminaries

Although not shown here, as with our previous demonstration, before working on canvas, I sketch a value pattern and paint a small color study. The value pattern will clarify the composition's balance of light/dark and its movement; the color study, which I keep next to my easel for ongoing reference, establishes the palette to be used.

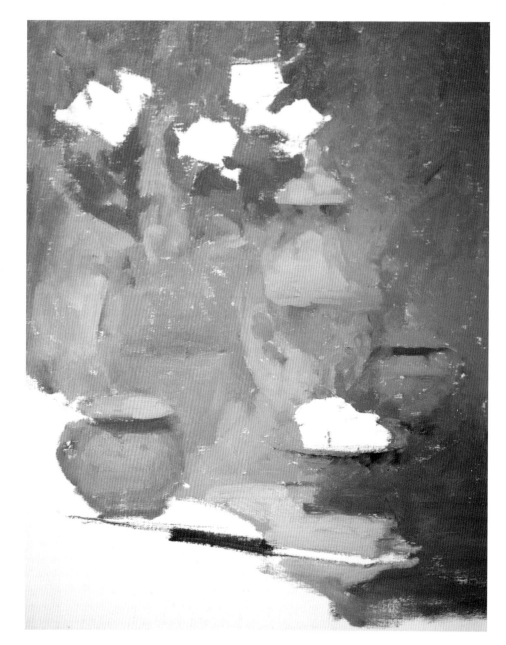

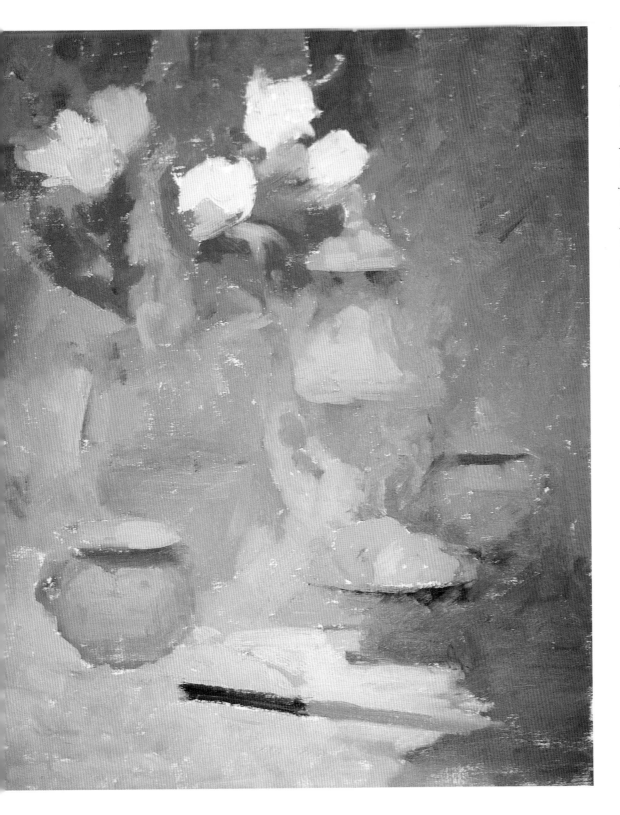

Moving on to the light pattern, I apply orangish mixtures to create the strong yellow of the lemons, and the softer, warm tones in the foreground. The roses are nearly white, tinged with soft, peachy tones. The canvas is now covered in colors that suggest the image to come.

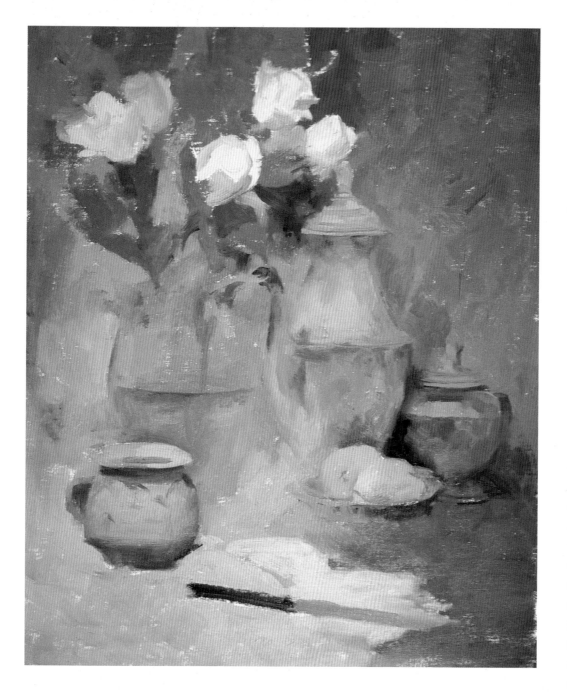

Now I turn my attention to the forms. Using thin paint, I carefully paint the shadows that shape each object. Although all are blue-toned, these shadows differ subtly from each other in their value, temperature, and intensity.

MARTHA'S HERITAGE

20 × 16" (51 × 41 cm)

Using thick paint, I model the lights to reveal form and space. The brushwork varies from object to object in ways that depict their surface texture. For instance, the silver's patina is suggested with broken color gently blended together and accented with sharp-edged highlights. The transparency of the glass is implied by the broad strokes of the background cloth continuing across the vase, while darker areas of water are painted with invisible strokes, set off with a crisp rim of light paint to define the water's edge.

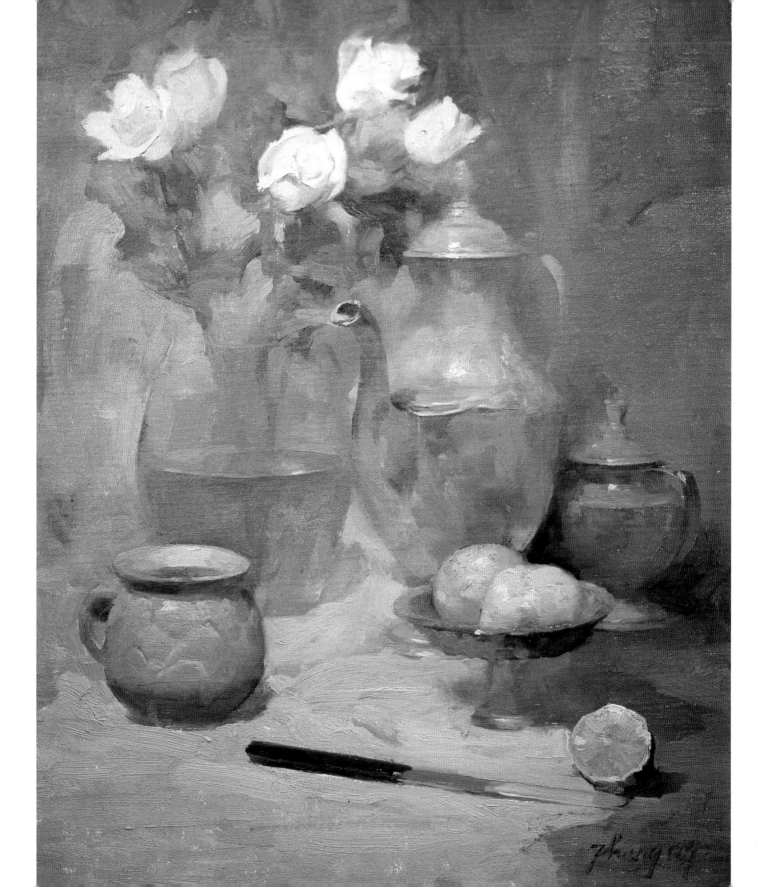

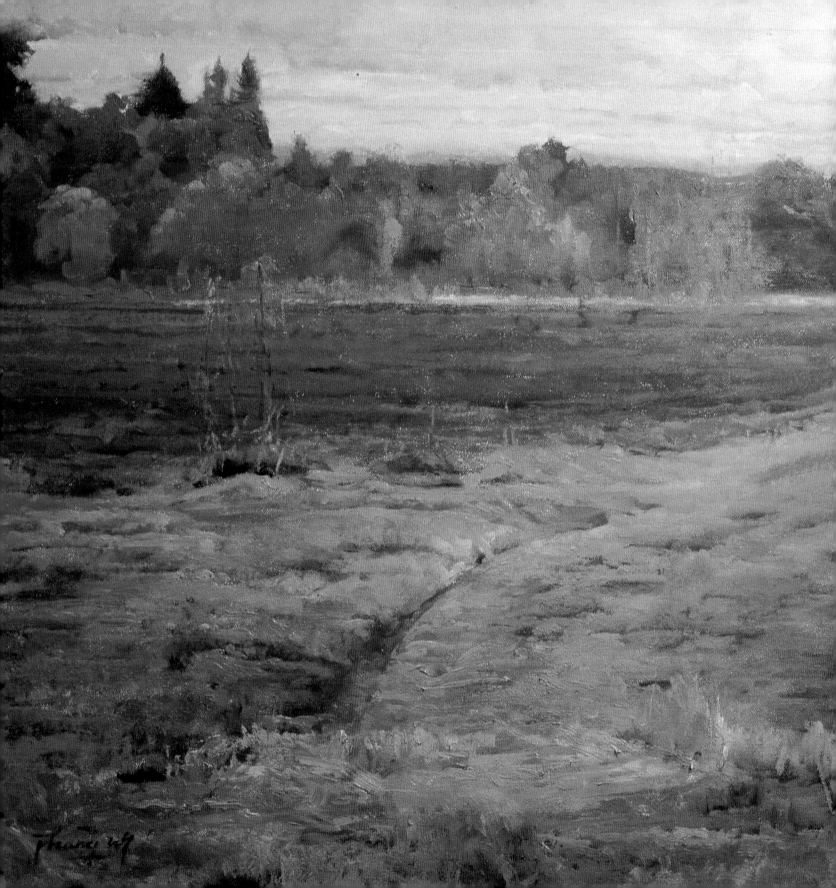

LANDSCAPE PAINTING

FARM ROAD

24 × 30" (61 × 76 cm)

*A good landscape is poetry. Poems and land-
scape both use just the right words—or strokes
of color—to convey a pervasive mood.*

PAINTING ON LOCATION

Landscape painting requires a clear understanding of what it is that moves you—the "ah" feeling that causes you to set up your easel in a certain place at a certain time of day. Is it the lighting? A particular color? A color relationship? Strong feeling can evaporate, so it's imperative to know the overall effect you are aiming for. And then, never change your mind!

Natural surroundings inspire you and provide the material for your creation, yet their appearance will change, even as you work. You must swiftly capture your impression. Then, once your canvas is covered, you will be in your own "wonderland." You will have recorded the essential color relationships, so any transient changes in daylight during the next three hours will not matter to you. You can pick and choose from nature only what enhances your wonderland. As long as you do not sway from your first intentions, your painting will keep a consistent mood.

USING ONE YIN/YANG PALETTE

One of the most common pitfalls for open-air painters is confused intentions. The painting that started out as yang becomes yin, the movement loses its contrasting visual support, the sunny patch that was intended to be the focal point disappears when the sun goes behind a cloud, and so forth. Having a clear idea of what your painting is about—and using yin/yang to catch the color and mood—will help prevent these disasters.

Try limiting your colors to one of the yin/yang palettes. Resist the temptation to squirt out extra color that doesn't belong. A color that seems beyond the range of your palette will actually feel more natural on the canvas when made with the yin/yang colors for that painting. Atmospheric color, that hallmark of fine landscape painting, is more easily achieved with the yin/yang palette.

PINK DAWN
(top)
8 × 10" (20 × 25 cm)

↘

LATE DAY, AUTUMN
(bottom)
6 × 8" (15 × 20 cm)

↘

One way to catch the short-lived color of sunset or dawn is by using miniature canvases; here are two examples of such tiny works. We use special paintboxes designed for this purpose. To overcome one of our pet peeves—finding materials that really meet our needs—we had a local cabinetmaker build pochade *(French for "sketch") boxes to our specifications. These boxes carry only a small supply of paint that is easily changed from one yin/yang palette to another, and their lids provide support for mini boards or canvases. We can mount them on a tripod, or, in bad weather, rest them in our laps to paint from the car.*

Preliminaries

Painting landscape on location requires time-management skills. It is essential to catch the light before shadows swing to the other direction. To save time in designing my composition, I usually resort to charcoal for my thumbnail sketch. Avoiding a linear approach, I mass in my patterns according to four values: dark, middle dark, middle light, and light. Then I catch the essential color relationships in a study on a tiny (4 × 5") canvas board. I chose a blue/orange palette for this scene since the orange foliage is the most exciting to me.

THUMBNAIL SKETCH

STEP 1

COLOR STUDY

I apply the color mixtures that belong to the dark, or yin, pattern. This yin pattern gives depth by meandering from the foreground through the middle ground to the distant background and sky. These blue/orange mixtures all favor their blue (yin) parentage.

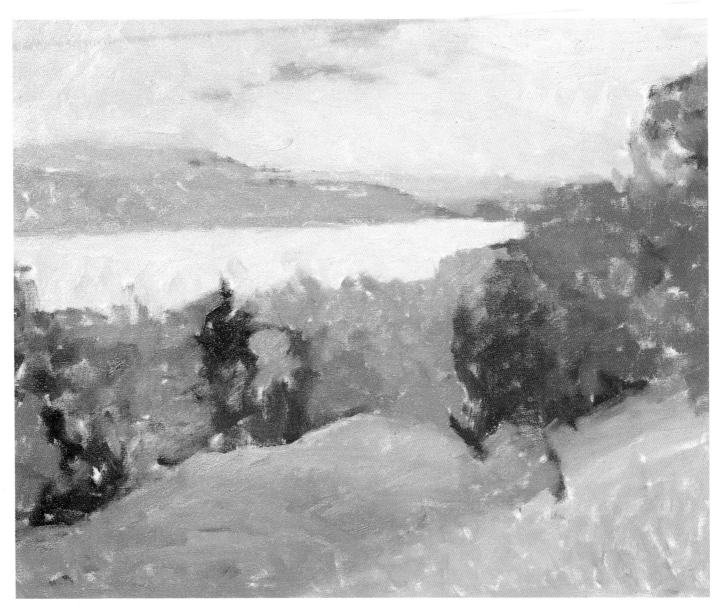

STEP 2

I swiftly cover the rest of the canvas with the yang pattern, mixing and adjusting the colors without hesitation. Just as one would move with speed when crossing quicksand, it is essential not to get bogged down in detail. The light changes too quickly. Yet, I haven't sacrificed subtle tonalities to the requirement of speed. The yin/yang comparisons of lighter, darker, warmer, cooler, brighter, and softer help me to make these distinctions quickly.

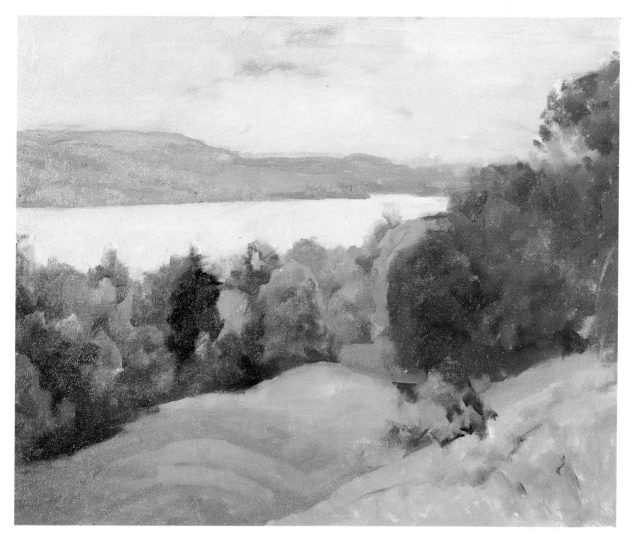

STEP 3

(above)

AUTUMN BY THE HUDSON

(right)

24 × 30" (61 × 76 cm)

I repaint the shadows in thin paint, carving out their shapes and recording the distinct color variations among their tones. I simplify the complex form of individual trees to basic solid shapes, such as pears, spheres, and cones. Elements revealing perspective, such as distance-related proportion and color changes, are necessary to the feeling of this work.

I model and refine the form, color, and details in the yang pattern, using a variety of brushwork to suggest the different textures of grass, leaves, and clouds. Thick application of lighter tones in the foreground heightens the perspective as well. Crisp accents of small detail, both dark and light, complete this one-afternoon landscape.

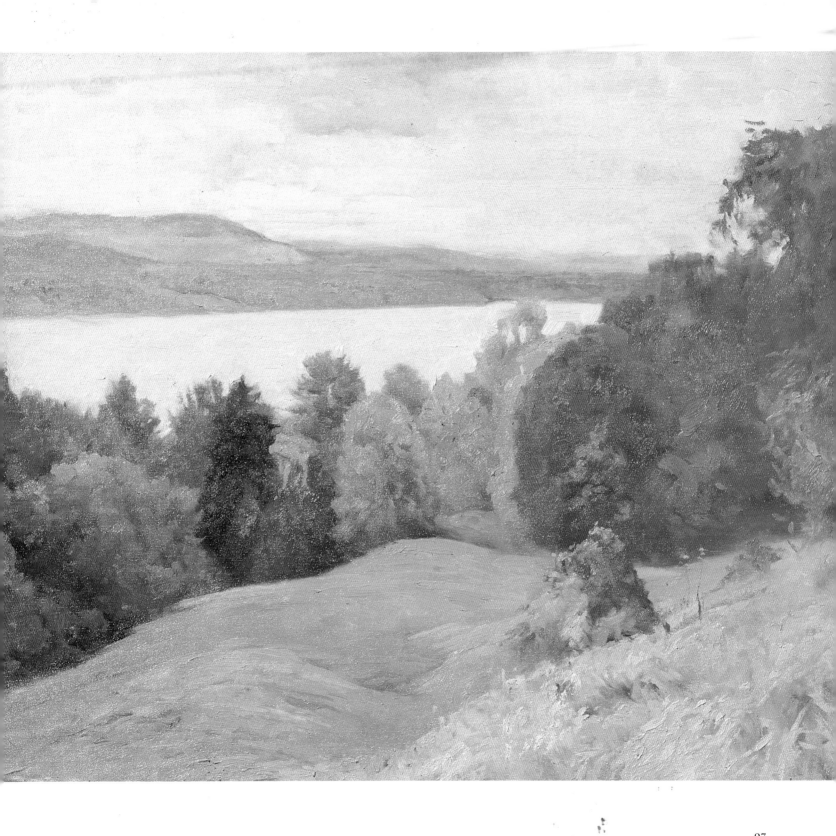

SERENE SCENE

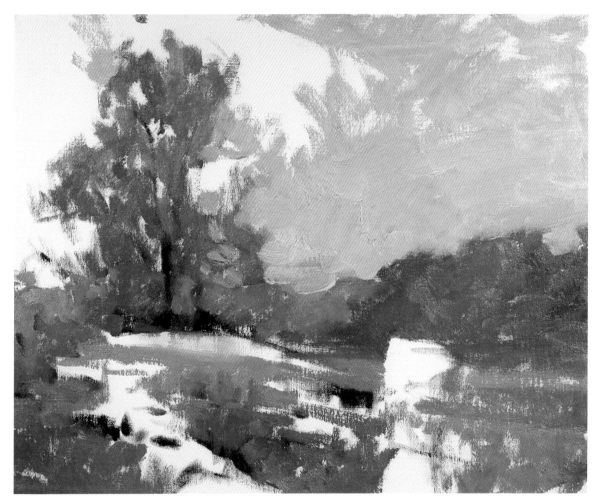

STEP 1

The dusky green colors of late summer pervaded this scene, so I chose a green/red palette. I lay in my colors for the yin pattern, using green mixtures, softened with small amounts of red. The foreground green is a stronger and warmer mixture; the middle-ground greens of the tree and hill are softer. The lavender color of the distant rolling hills was created with a highly neutral mix of cold green, cold red, and white. Even the sky was created with a light, neutral mixture.

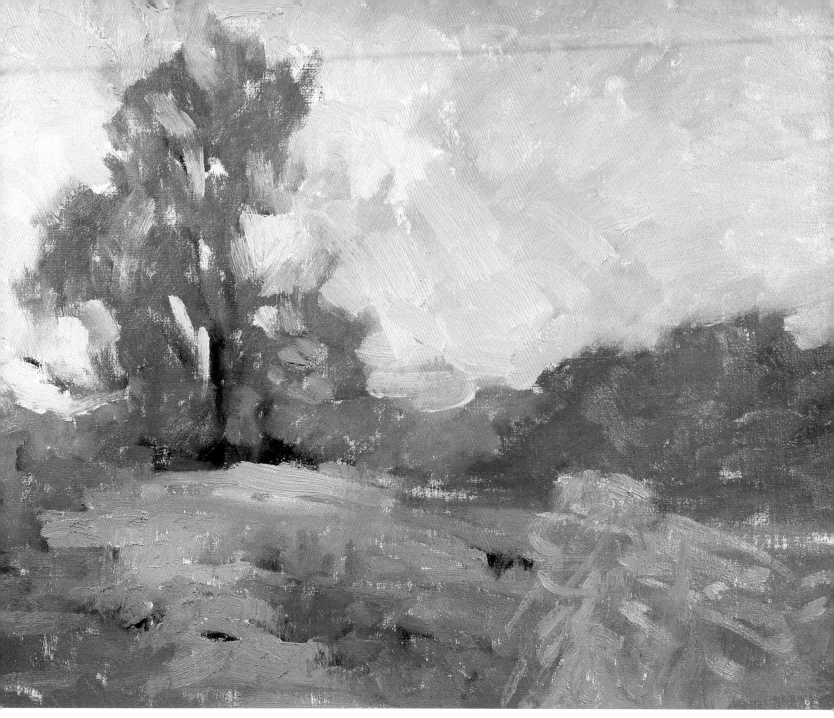

STEP 2

I cover the rest of the canvas with color mixtures for the yang pattern. These mixtures of various reds with greens are neutral, since they lean only slightly toward red. The flowering grasses in the foreground are a bit more intense; the cloud behind the tree is a very neutral pink.

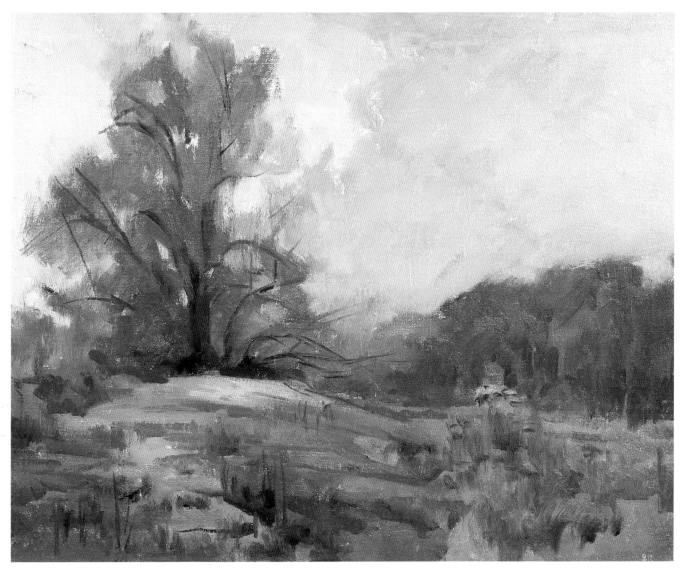

STEP 3

(above)

TRY TO REMEMBER

(right)

16 × 20" (41 × 51 cm)

Now I turn my attention to giving form to the landmarks that suggest the layers receding into the distance. Using thin paint, I carefully paint the shadows that give shape to the trees and clumps of grass. Although all are green tones, these shadows differ subtly from each other in their value, temperature, and intensity.

Using energetic brushwork, I model the lights to reveal form and space. To suggest the masses of foliage, I develop the sky between the branches. Small but important details are added. Branches and tree trunks lend realism to the stand of trees; thick paint helps describe the flowering meadow grasses, bringing the foreground closer.

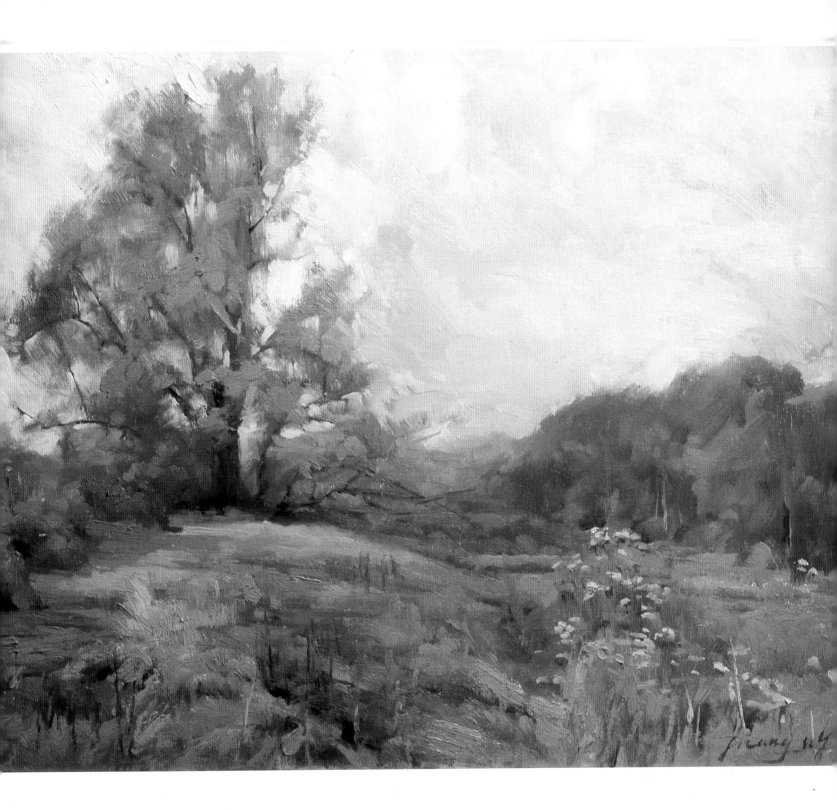

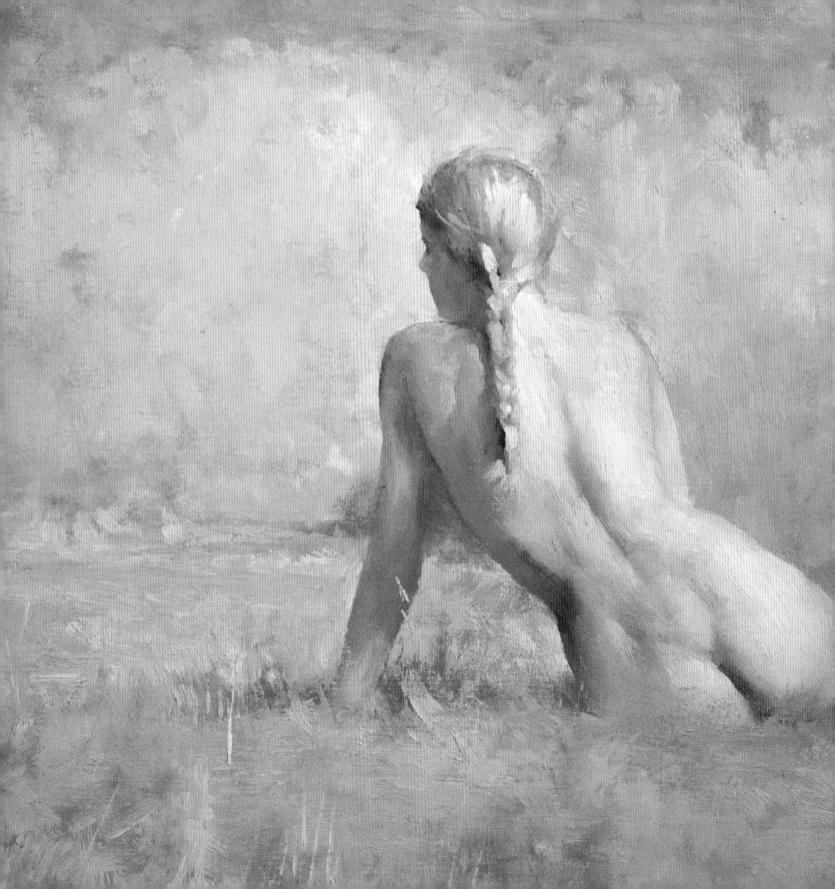

FIGURE PAINTING

INDIAN SUMMER

20 × 24" (51 × 61 cm)

The clear blues and oranges of this perfect autumn day are reflected in the neutral color mixtures for this nude's flesh tones. Shadowy flesh tones lean more toward their blue component (blue violet, cobalt blue or phthalo turquoise blue), while the flesh tones in the sunlight lean more toward their warmer, orangish pigment (cadmium yellow deep extra, cadmium orange or cadmium red scarlet.) True to the yin/yang palette for Blue/Orange, yellow ochre was not used at all, not even in her hair.

HUMAN FORMS AND FACES

Figure painting has a long tradition, much older than still life or landscape. The human form and face have always been favored subjects for painters, going back even to prehistoric art. The reason is obvious: Nothing is as interesting to humankind as humankind. That is the way we are all wired.

Paintings with a person in them tell or suggest a story. The story told can be quiet or dramatic. It may be a genre scene, depicting everyday life, or a historical painting describing an event or expressing a political point of view. No matter what the scene is about, when the subject in a painting is a human being, we as viewers identify with that person. In our hearts, even if only for a second, we go to the scene where that person is and feel his or her experience.

THE NUDE

It is standard training to study oil painting by painting the nude. There is nothing as technically challenging and potentially beautiful as capturing flesh in oils. By the time art students become accomplished at painting the nude, they will have mastered skills that easily adapt to the other genres of painting.

Painting nudes helps us learn how to paint complex forms that have beautifully neutral, slightly translucent color—so neutral that it reflects colors from surrounding areas. We need to discover the miracle of neutral color—that the most deadly neutral on the palette oftens looks perfect on the skin of the nude.

NUDE STUDY

40 × 30" (101 × 76 cm)

Colors on your palette that would seem unlikely choices for portraying flesh often turn out to be the perfect ones to use in figure painting. For example, cinnabar green light extra, bright violet, and a little raw umber were combined to create some of the rich, yet subtle, shadowy flesh tones in this nude. Her skin in the light is depicted with various mixtures involving cadmium yellow, cadmium yellow orange, yellow ochre, or raw umber, with magenta or bright violet and titanium white. The strongest light, on her shoulders, contains some cinnabar green light extra.

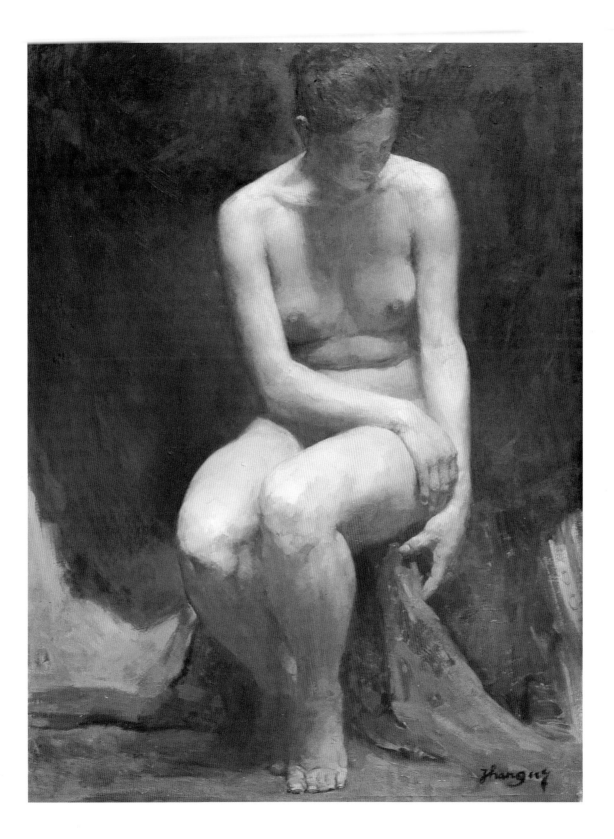

IN THE WOODS

18 × 24" (46 × 61 cm)

Everyone knows that the natural landscape feels wonderfully alive with a person in it. I have found that the nude feels beautifully natural in the landscape. The effect of outdoor lighting and the reflected tones of surrounding vegetation are exquisite. In painting, nudes and nature belong together.

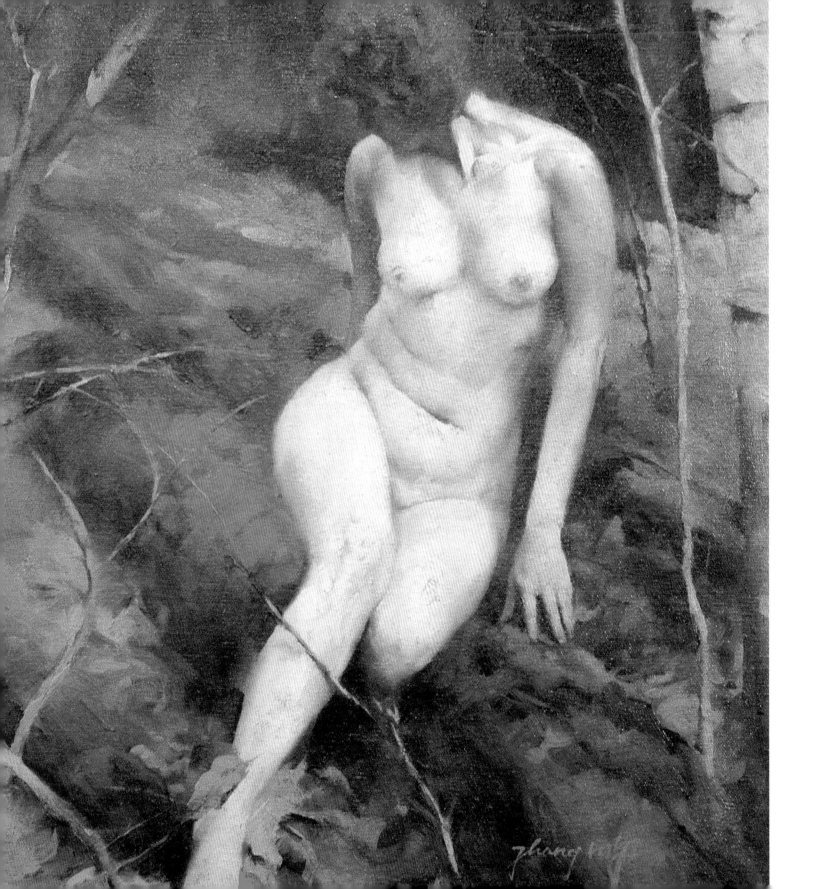

CLOTHED FIGURES

After learning to paint believable nudes, painting a clothed figure to appear three-dimensional becomes easier. The sense of form and knowledge of human anatomy gained from nude study is indispensable here, so that a painted figure does not look like a head stuck on clothing suspended from an invisible hanger.

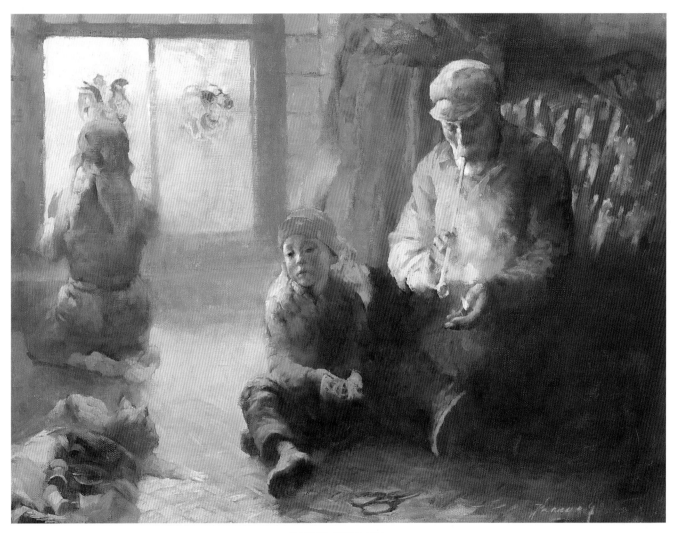

PAPER CUTTING

24 × 30" (61 × 76 cm)

This painting draws on my experience in Yu Xian village during the Cultural Revolution. The local farmers decorated their humble adobe homes with colorful paper cuttings for Chinese New Year. This traditional folk-art activity was an important custom in family life, especially for children.

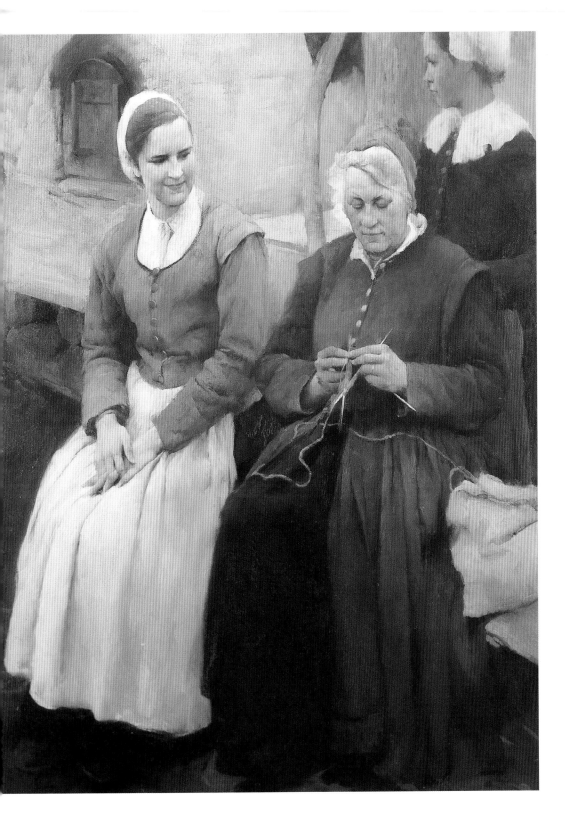

KNITTING

40 × 30" (101 × 76 cm)

How a body is structured inside cloth-ing—where the figure's "landmarks" are located—was carefully considered here. Certain parts of the women's clothing help suggest their body con-tours. For instance, the curve of the apron's waistline reveals the round-ness of one woman's belly. The draped cloth of their skirts suggests their thighs beneath.

FEMALE NUDE

VALUE STUDY

In this value study, the figure, the canvas on the easel, and the towel on the floor combine to form the light, yang pattern. This undulating pattern echoes the woman's pose. The dark, yin background gives strong support to the model's shape.

Preliminaries

Just as we explored in the chapters on still life and landscape, for a figure painting, as well, we plan the compositional space with a value study and then a color study. At this stage, I am not interested in the figure per se, only in its role in the play of patterns.

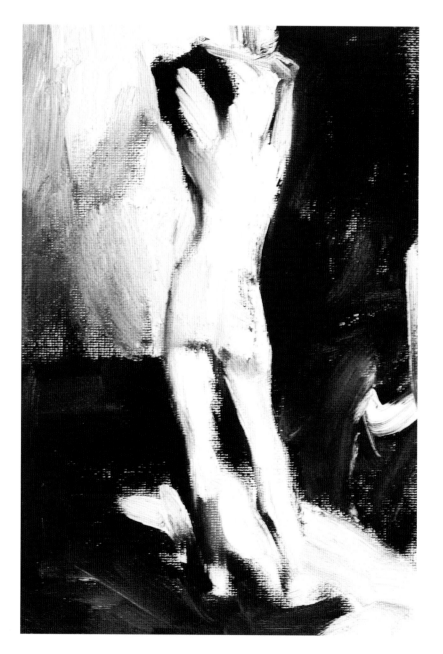

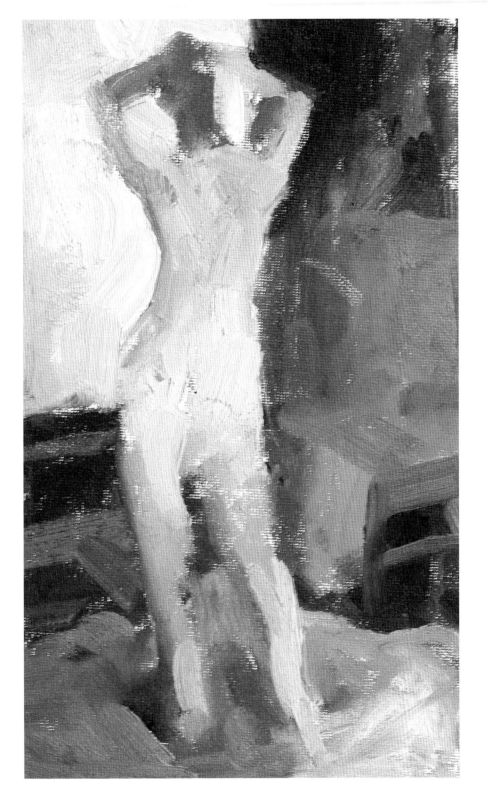

COLOR STUDY

This color study follows the design of the value study (opposite), using the complementary hues of green (yin) and red (yang).

STEP 1

For my initiial drawing, with angular strokes I lay out the figure and surrounding objects, recording just the key lines showing perspective, proportion, and anatomy. Only my thinking is careful; the drawing is actually quite free. (See the loose strokes for placement that have nothing to do with contours.) The paint mixture is a yin (greenish) neutral that will melt into the yin pattern of the next step.

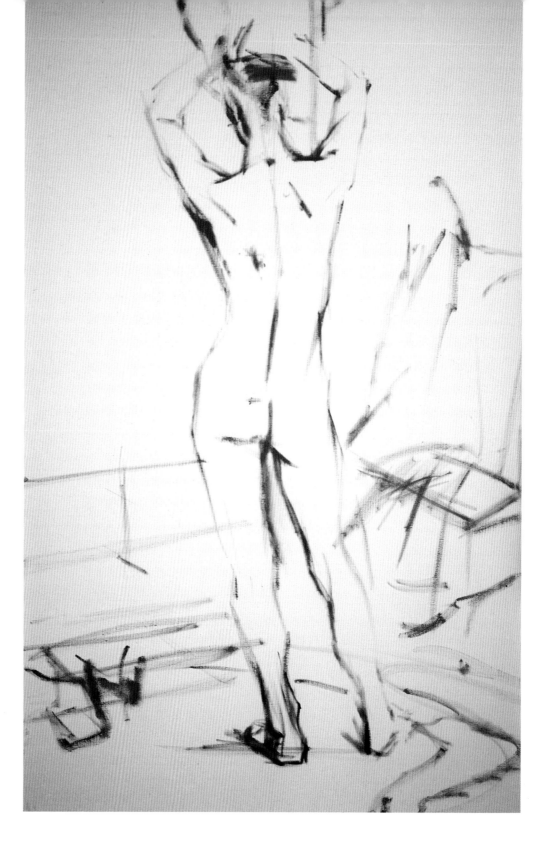

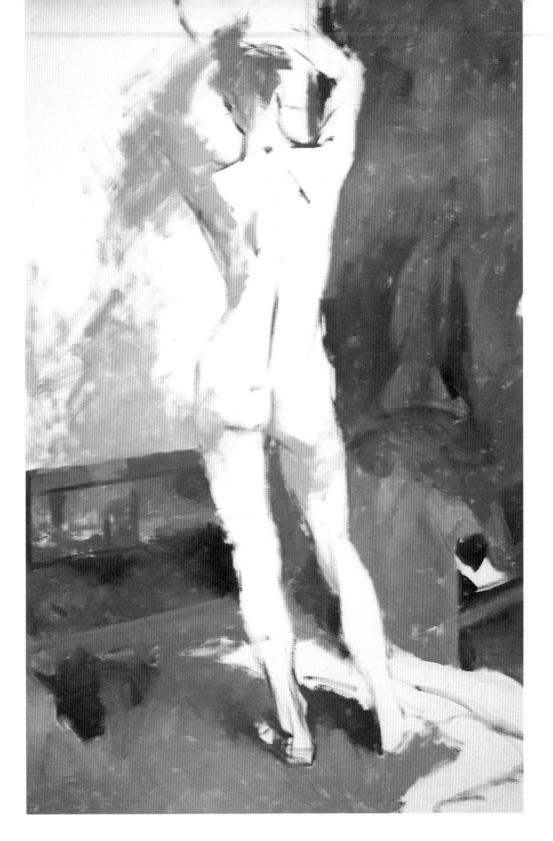

I paint the yin pattern, adjusting the reddish-green mixtures to change their value, temperature, and intensity where needed. I always do the dark (yin) pattern first because its relationship to the white canvas always displays the movement pattern—the chi. These darks also anchor my values so that the flesh tones will be healthy ones.

STEP 3

I cover the rest of the canvas with yang family colors. Since the darker colors are already on the canvas, it is easier to get the right skin tone. I use the neutral red mixtures from my palette. These neutrals are very sensitive. On the palette they almost appear "gray," but with the slightest adjustments for value, temperature or intensity they describe all the different skin tones of the figure in front of me. Before going on to the next step, I remove excess paint by scraping it with my palette knife.

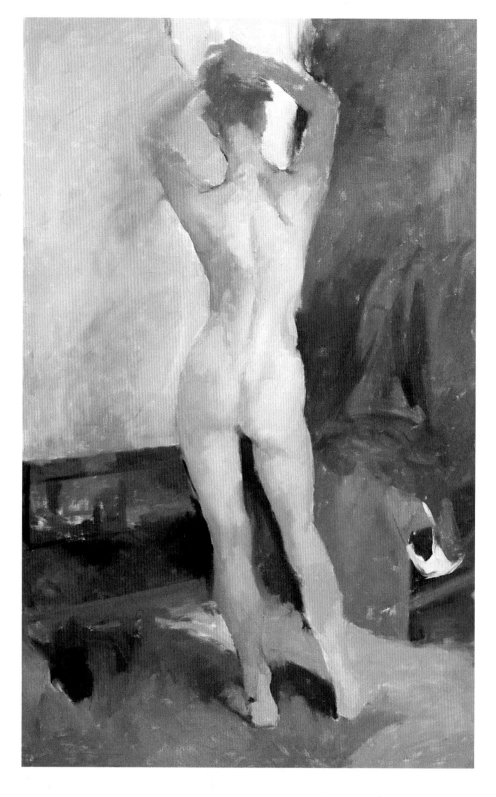

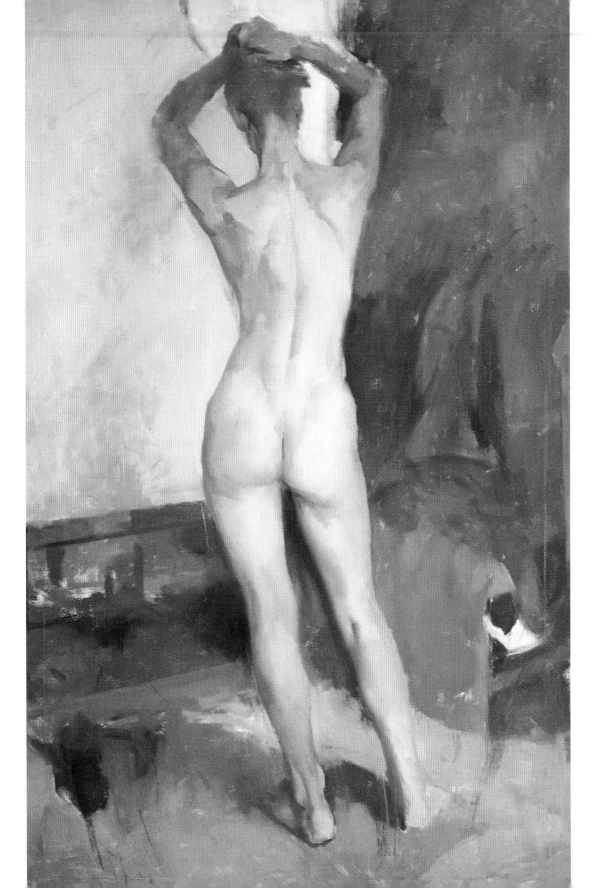

I refine the dark shadows, paying careful attention to their shapes and tones. Being more focused now on the beauty of the anatomy, I use the shadow color—all various tones of neutralized greens— to show the important underlying bone and muscle.

115

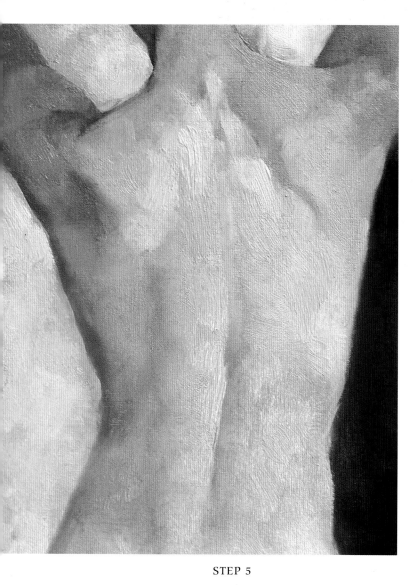

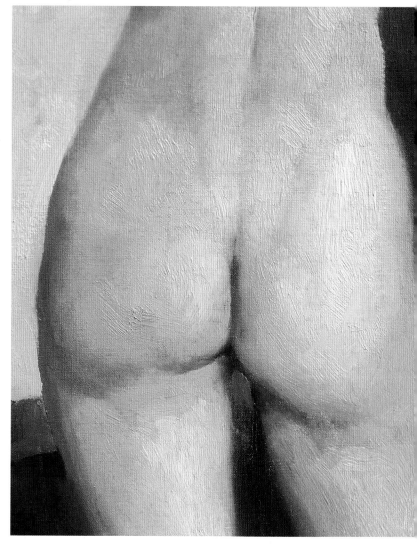

STEP 5

STEP 6

With a fully charged brush, I model the light areas. This detail reveals how my brushwork builds the muscle and moves light-valued paint into the shadow, turning the form.

The warm reds meeting the shadowy greens create a surprisingly rich middle tone, as shown in this detail.

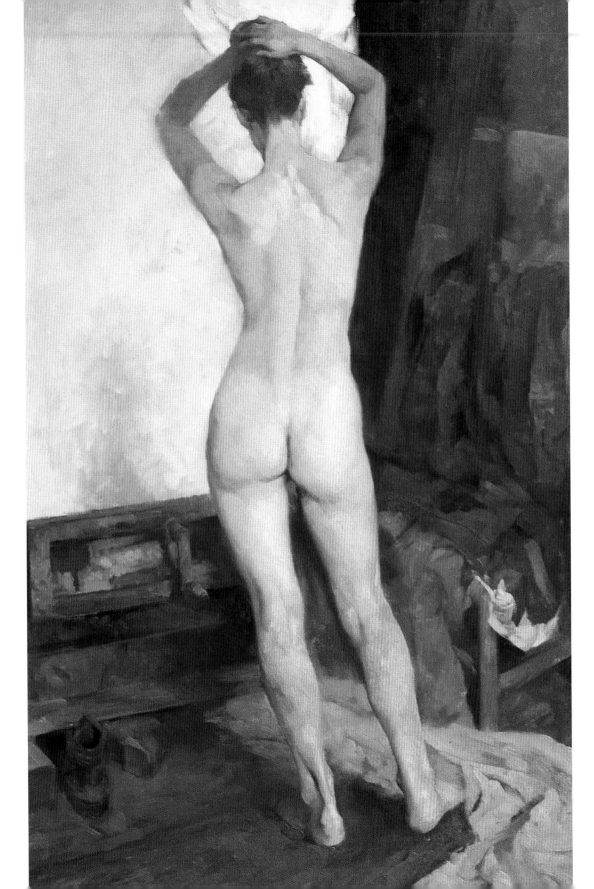

THE BLANK CANVAS

48 × 30" (122 × 76 cm)

After completing the two previous steps in all areas of the canvas, I add a few crisp darks and highlight details. Now the painting is complete.

DEMONSTRATION
PORTRAIT OF A CHILD

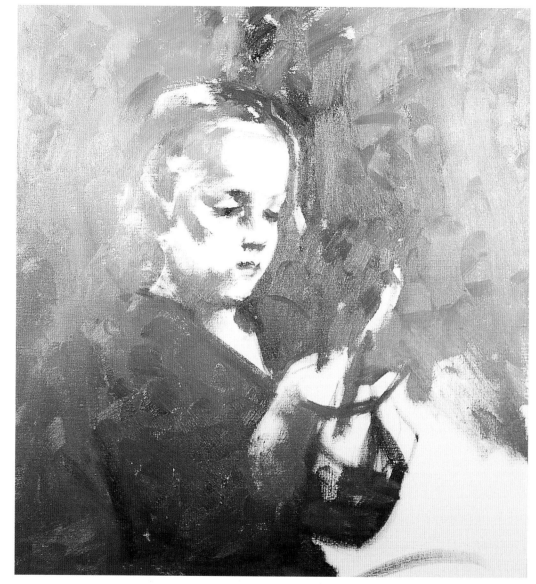

STEP 1

I chose a green/red palette for this painting. Thinking about the pattern, I draw the subject and paint in the dark areas, using mixtures of cooler greens and reds that lean more toward their green component. Most of these colors were created by mixing phthalo turquoise blue, bright green, or green earth with magenta or cadmium red deep, and sometimes adding titanium white or ivory black.

STEP 2

(right)

I cover the rest of the canvas by painting the lighter areas with a fully charged brush. These lighter areas are mixtures of warmer reds and greens that lean more toward their green component. The colors used here are made from cadmium red light, cadmium red deep, magenta, Venetian red, cinnabar green light extra, bright green, titanium white, and sometimes a little ivory black.

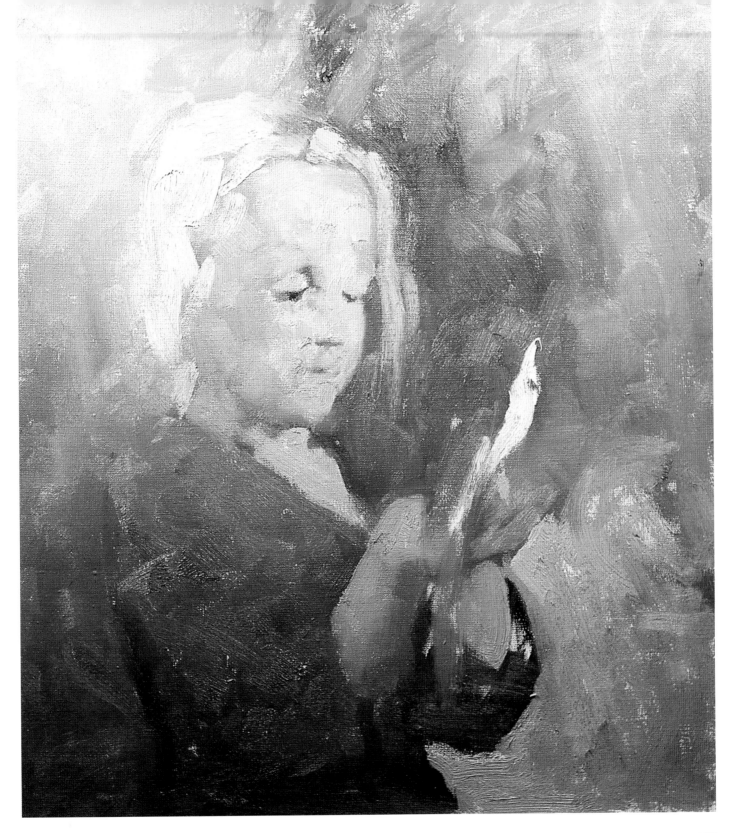

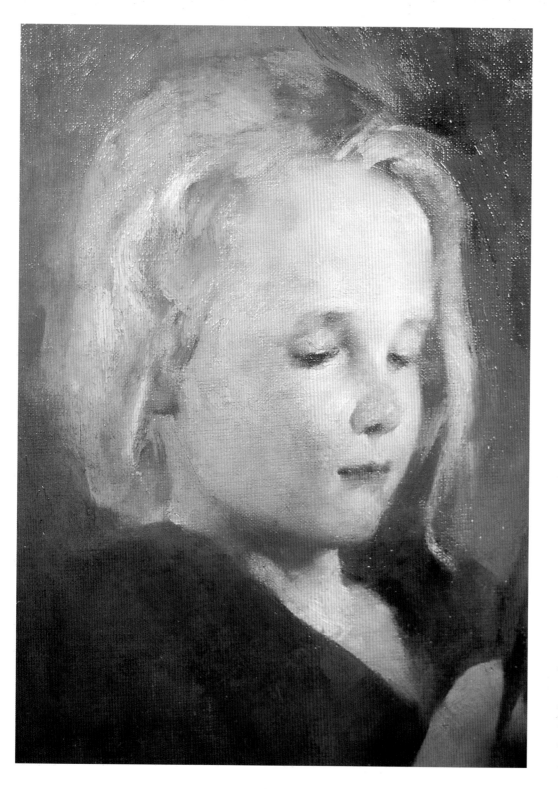

I model the forms with varied strokes, moving the paint between the light and shadow. My brushstrokes on the child's hair go in many directions, with only a few highlight strokes indicating key strands. Using a soft brush, I apply the strokes on her skin very gently, often using the side of my brush.

GIRL WITH BIRD

(right)

22 × 20" (56 × 51 cm)

The colors in the bird reveal the green/red color scheme of this painting. The muted dark greens give a dreamy quality to this portrait. They also set off the girl's peaches-and-cream complexion to great advantage. Glazes enhance the rosy tones in her face.

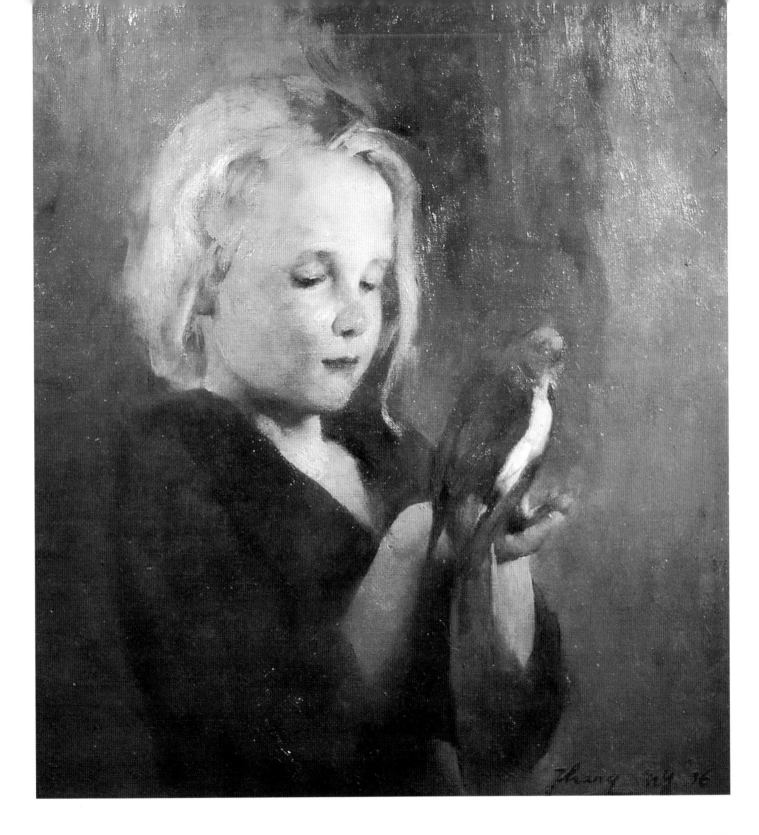

GLAZING

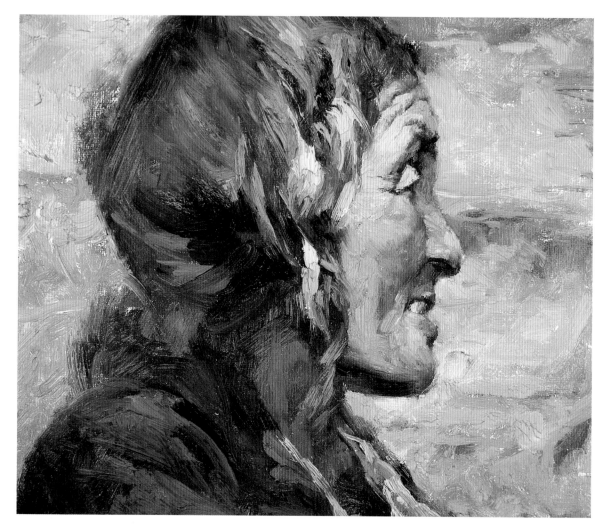

STEP 1

To enhance this portrait, after completing steps similar to those described in the previous two demonstrations, I apply a glaze to the dried surface.

Since human skin is translucent and has local color variations, glazing is a useful technique for portraying realistic skin tones, and it also heightens the atmospheric effect. For the glaze, I mix only transparent paints with a glazing medium made of equal parts stand oil and mineral spirits. Applying a vitreous layer of greens with a stippled-brush technique, I vary this layer from warm to cool in a random, mottled way to show the vibration of air and to unify atmospheric color.

UNDER THE SUN

16 × 12" (41 × 31 cm)

To complete the glazing process, I use a neutralized blue glaze mixture to strengthen the shadows, thereby heightening the form. Then I apply some magenta glaze color to the woman's rosy cheeks, telling the story of her years in the sun.

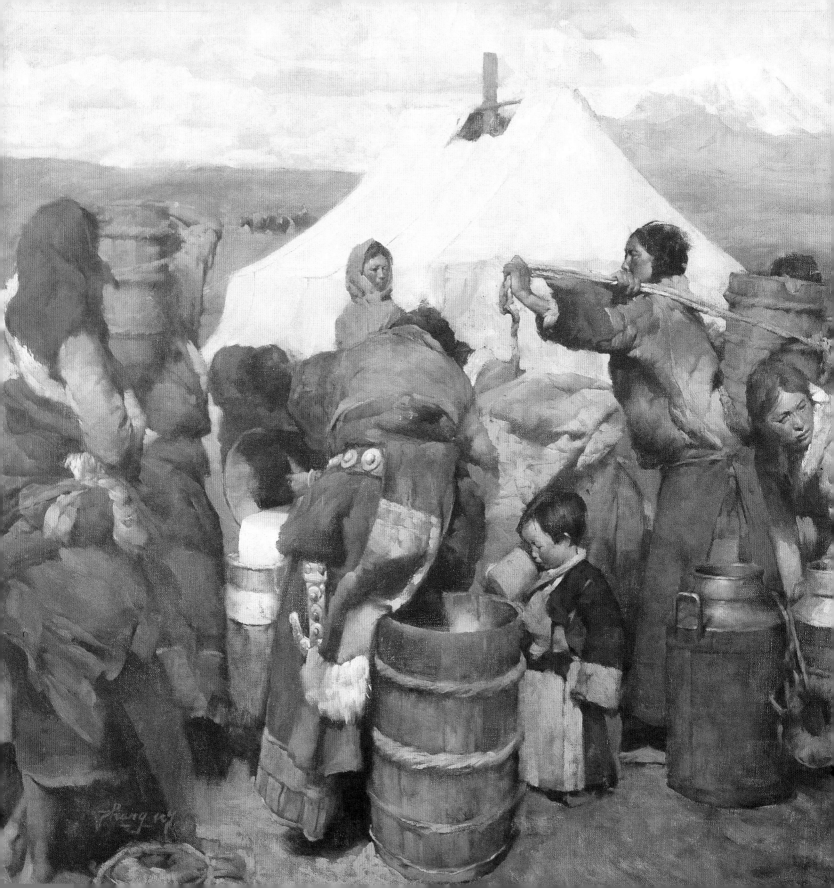

MULTIFIGURE COMPOSITIONS

TIBETAN WOMEN COLLECTING MILK

(detail)

33 × 57" (83 × 145 cm)

In 1989, I had the unexpected privilege of witnessing a Tibetan milk-collection event. Farm women dressed in holiday clothes come from great distances, carrying their casks filled with yak milk. This social gathering was alive with a spirit of camaraderie. The sunlight and bright colors defied the harsh reality of their landscape. I took many photographs and filled a sketchbook, but did not put their images together until years later. Reflecting on this memory of heroic women toiling on the roof of the world allowed my imagination to spring forth a composition.

PORTRAYING GROUPS OF PEOPLE

I like paintings of people working and living together, relating to one another and their natural surroundings. They show real life. Multifigural paintings are my special love, since the universal harmony among people is my ideal. This form of painting allows me to explore and show my feelings about humanity. I feel the symphony. When I see people together of different races, classes, or generations, it is as if I'm hearing the same music played simultaneously by different instruments in an orchestra. This variety inspires me to be their composer and conductor. The gestalt of their different poses, body language, and expression moves me. They are dancers on the stage of life.

How I arrange them, where I put the movement along the figures, how I link them to the pattern, what *chi* the pattern suggests—all require the power of yin/yang thinking to bring order to chaos. The abstract pattern and the movement linking the figures are essential in multifigural composition. They are the visual path for the eye to take. Without such a path, the eye will wander away.

MOVEMENT PATTERN

To help me find and establish the most effective movement, I often ask myself, *Where is my dragon?* This is because the movement that often winds through a painting in an abstract pattern reminds me of a dragon. After thinking it through, usually by doing several rough studies, I will have developed a really useful visual idea.

MOVEMENT STUDY

Do you see the lively movement that resembles my hidden dragon in this color study? Comparing it with the finished painting on the previous page spread will show how useful my dragon was in guiding the composition and movement of the painting.

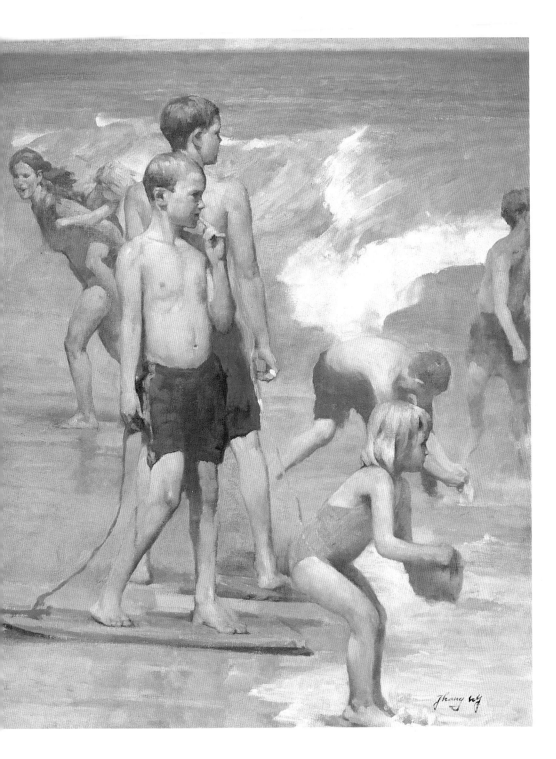

MOVEMENT STUDY

This study shows the hidden movement that characterizes The Wave.

THE WAVE

40 × 30" (101 × 76 cm)

The contrast between the boys' moment of pause and their active surroundings is a yin/yang contrast that strengthens the tension in this multifigure composition.

SMALL GROUP, INTERIOR SETTING

Preliminaries

There is more compositional planning involved in the multifigure composition than in other genres of oil painting. Above all, I strive for a yin/yang balance of the figures' poses and their placement. In this example, most of the dancers are bent over; one is sitting up. One figure is in the foreground, two in the middle ground, and one in the background.

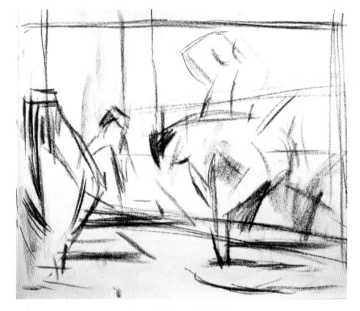

CHARCOAL STUDY

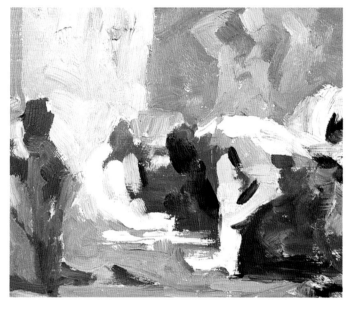

VALUE STUDY

I usually do several rough charcoals before determining which poses are desired and their relationship in space to one another. Of the many I tried in this case, here is the one I chose.

It is essential to do a compositional value study before starting a multifigure painting. The canvas will feel cluttered with people and objects unless they are connected to one another by the design. Here, I linked the light background wall with the dancer seated on the floor. This yang pattern then swings down in front of her to bounce up the red-haired dancer's leg and arm, and then arcs from her neck to the right along her back and ends with the draped clothing behind her. The other two dancers melt into the yin pattern.

COLOR STUDY

The atmosphere of this dance studio felt more blue-gray to me, so I selected blue/orange as my yin/yang palette. The application of blue to the darker, cooler yin, and orange to the lighter, warmer yang was facilitated by my previous value study. Now I am ready to do a more careful drawing of the figures.

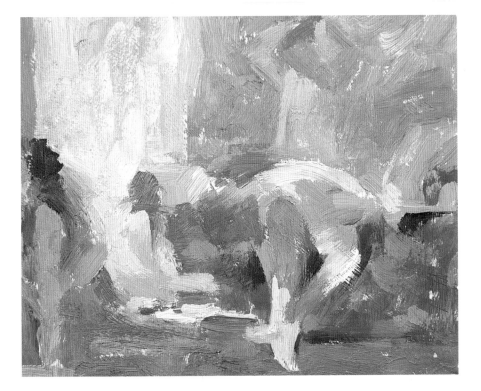

STEP 1

For my initial drawing, I lay out the figures with careful attention to their gestures, proportions, and perspective. I am careful only with those three issues; the actual drawing is quite loose. I use a yin mixture (blue softened with a drop of orange) that will melt into the darks later.

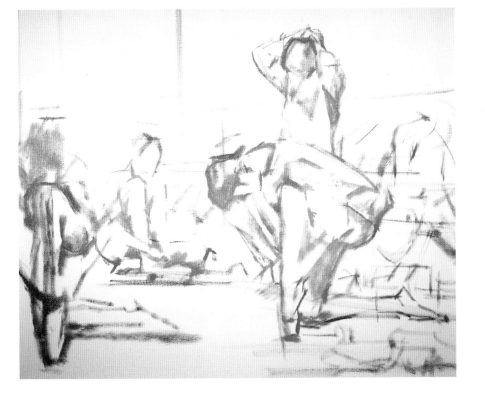

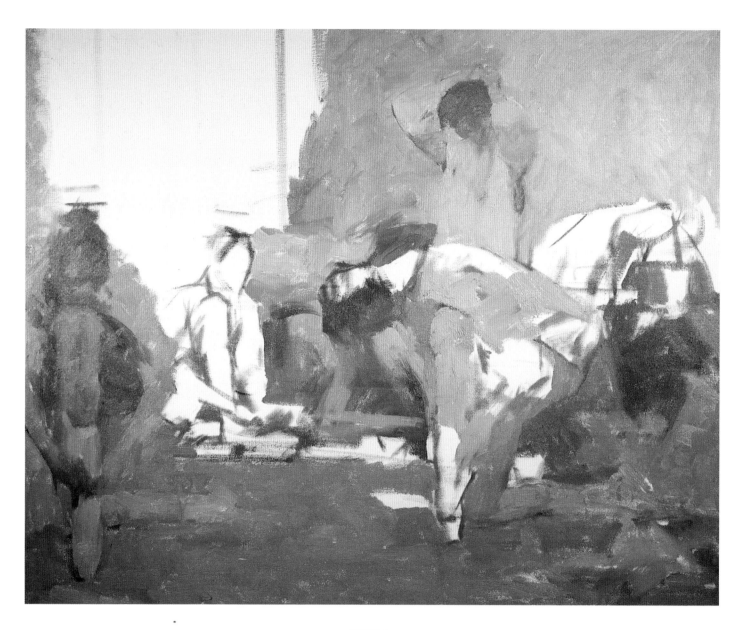

STEP 2

~

Applying color to areas of the yin pattern, I adjust the orangish-blue mixtures as I go to reflect my observations about change in value, temperature, and intensity. Some areas of the yin are fairly light and highly neutralized with orange, but still are yin. They will feel more blue when the yang pattern goes down.

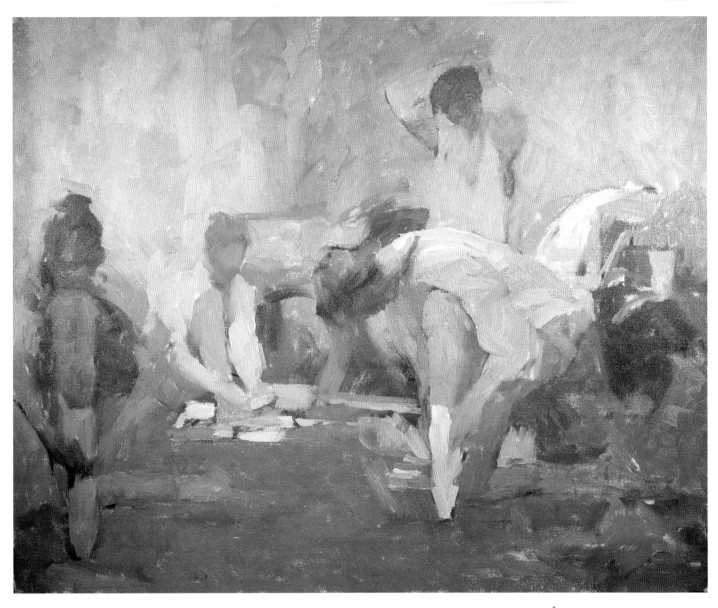

STEP 3

I cover the rest of the canvas with colors that apply to areas in the yang pat-
tern. Again, just as in the first step, I adjust my bluish-orange mixtures as
I go to reflect my observations about changes in value, temperature, and
intensity. Now I scrape the entire canvas with a palette knife. This removes
the excess paint that would impede further brushwork. Scraping also gently
softens hard edges.

STEPS 4 AND 5

In a multifigure painting, the time required for repainting all the shadows and then repainting all the lights usually exceeds the time available on one work day. Since the paint from Step 4 should remain wet during Step 5, I paint these steps together, one figure at a time. I redefine and strengthen the shadows, paying careful attention to their shapes and tones. Comparing shadow to shadow helps determine their nuances in value, temperature, and intensity. I use a thinner paint application, often with a softer brush.

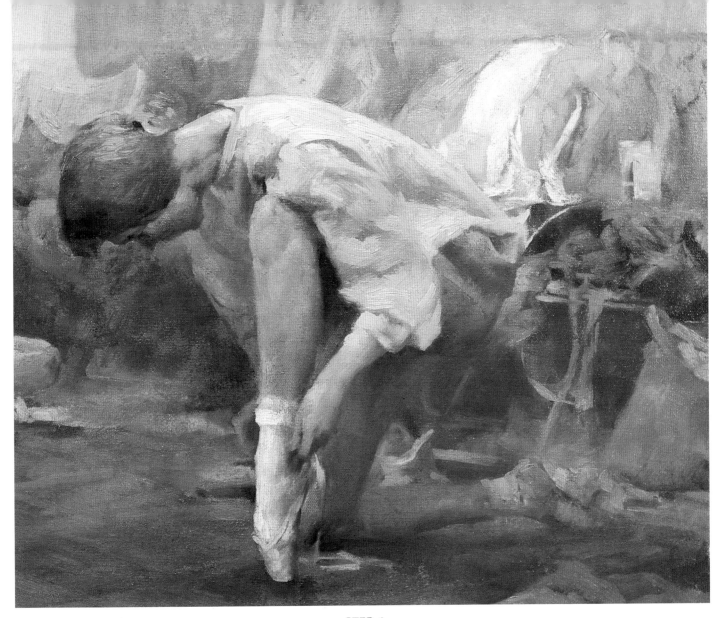

STEP 6

With a fully charged brush, I model the light areas. The brushwork really matters here. I use different stroke length, direction, pressure, and speed to suggest the appropriate texture, energy, and rhythm. Where light meets shadow demands special attention. The color there is not only from the palette, but also from mixtures created on the canvas between yin and yang paint. Varying the pressure and direction of the brush changes how the colors combine. I usually wipe my brush clean after each mixing stroke, to avoid weakening the next.

DANCING SHOES

24 × 30" (61 × 76 cm)

To finish the two figures on the left and the standing figure in the background, I follow the same procedures I used in the previous steps for the bent-over figure. Now the painting is completed.

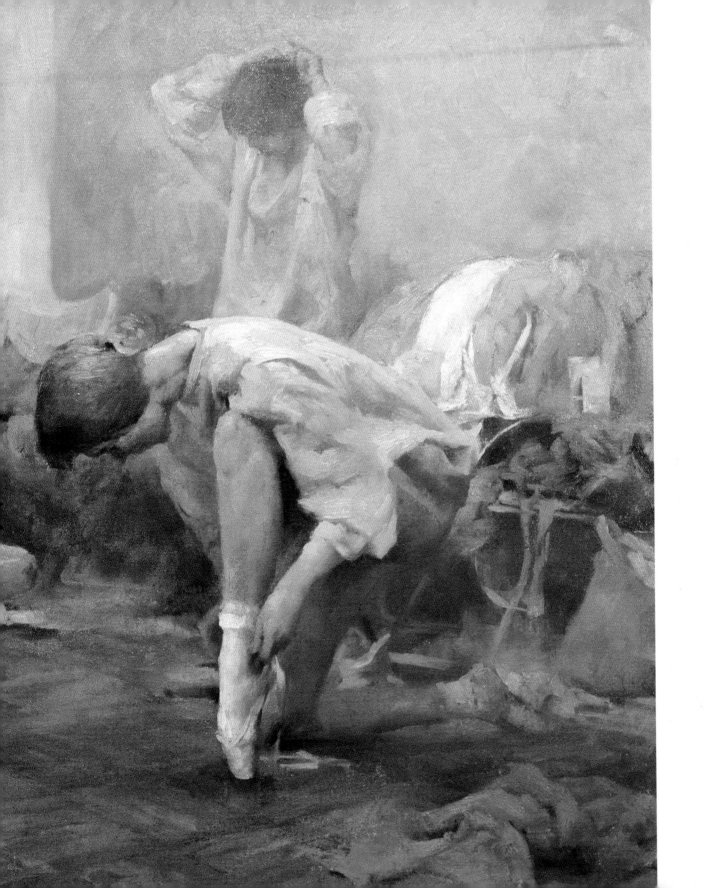

DEMONSTRATION
LARGE GROUP, OUTDOOR SETTING

STEP 1

This detail shows how I loosely block in colors, working from the dark pattern to the light. My palette consists of the green/red pigments, plus black and white. My darker and cooler tones were created with mixtures involving phthalo turquoise blue, bright green, or green earth with magenta or cadmium red deep, and in some places, ivory black and titanium white. These color mixtures all lean more toward the yin, green side.

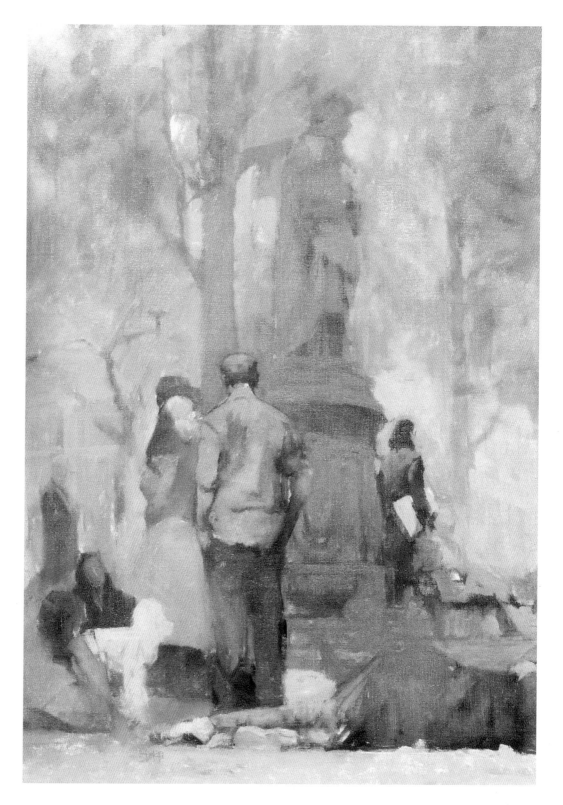

STEP 2

I continue covering the canvas, still working from the dark pattern to the light. The lighter, warmer tones are based primarily on cinnabar green or bright green with cadmium red light or cadmium red deep, plus titanium white. I continuously bring more intensity to the colors in the foreground figures to help build a sense of space.

UNION SQUARE

40 × 70" (101 × 177 cm)

I model the forms, one by one, working from dark to light, being as careful with the space between the figures as the three-dimensionality of the figures themselves. This sense of space lets one's eye travel into the painting. The differences in color, value, and edges among foreground, middle ground, and background elements give rise to this spatial experience. A final touch of warm green glazes enhances this painting's springtime aura.

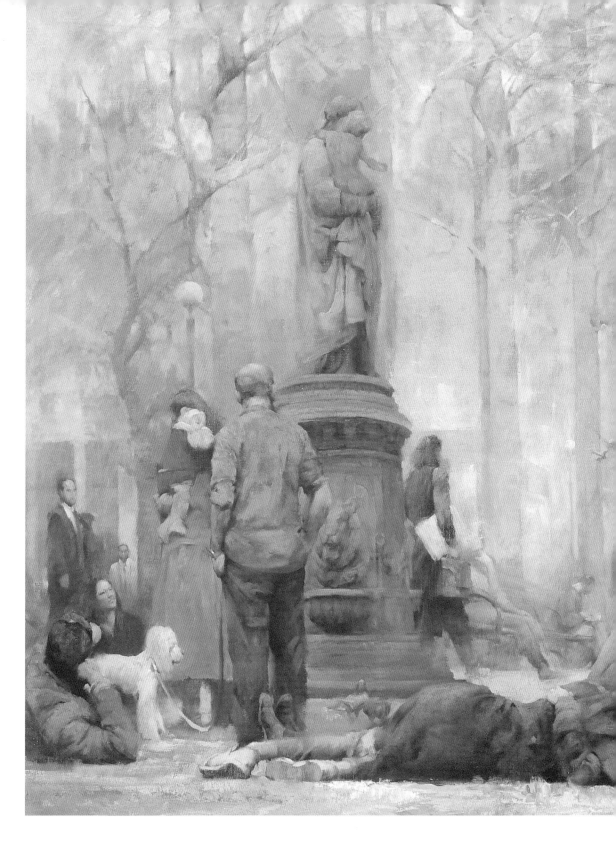

AFTERWORD

By now, whether you've applied all or some of the principles we've covered to a painting of your own, or are just getting ready to put them into practice, you have undoubtedly grasped that yin/yang is a way of looking at the world to gain better understanding of it. Opposites support and complete each other, and together, they become one.

Remember that art is a language, and these yin/yang principles will help you gain fluency in telling your story, sharing your point of view.

The *I-Ching,* the ancient "bible" of yin/yang, outlines sixty-four combinations of the philosophy, explaining the mysteries of existence. But this book is not an *I-Ching* for art; we cannot explore the infinite combinations of yin/yang that there may be. However, we do believe that the more you embrace the concept of yin/yang, the more applications of it you will discover for yourself. We hope that by opening the door to your yin/yang journey, we will have helped you toward reaching that goal.

BALLERINA

24 × 20" (61 × 51 cm)

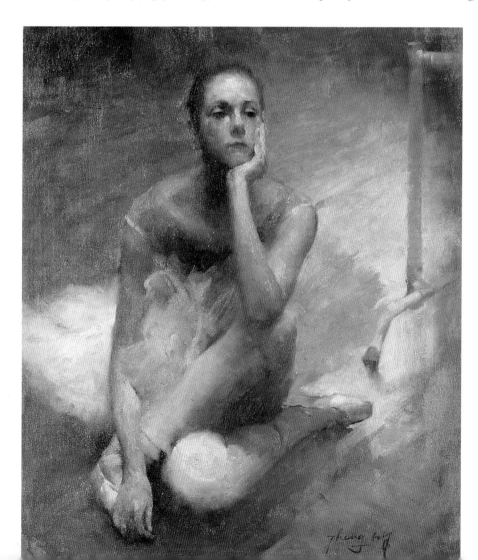

MATERIALS

Oil Paint

Of the many brands of oil paint on the market, we generally prefer Old Holland for our own works. When students buy paint, however, often the cost of oils leads them to be stingy in the amount of pigment they put on their palette—but no one can learn to paint well without using a lot of pigment. For that reason, we suggest that beginners use a lower-priced, student-grade paint, such as Daler-Rowney Georgian, then change over to artist-grade when budgets permit.

Whether you choose these brands or others, be sure to have all the colors that make up the pimaries (red, yellow, blue), secondaries (orange, green, violet), and tertiaries (a mixture of two of the three secondaries), plus white and black. Note that pigments of the same name often vary among manufacturers, so you should view any color before buying it. Also, certain colors,. usually in the tertiaries, are missing from some brands, so we suggest jumping to a different brand for those, as noted with asterisks in the lists below.

COLOR	OLD HOLLAND (ARTIST GRADE)	DALER-ROWNEY GEORGIAN (STUDENT GRADE)
Yellow	Cadmium Yellow	Cadmium Yellow Light
Yellow Orange	Cadmium Yellow Deep Extra	Chrome Orange
Orange	Cadmium Orange	Chrome Orange Deep
Red Orange	Cadmium Red Scarlet	Cadmium Red Light
Red	Cadmium Red Deep	Cadmium Red Deep
Red Violet	Magenta	Magenta
Violet	Bright Violet	Cobalt Violet
Blue Violet	Blue Violet	Blue Violet**
Blue	Cobalt Blue	Ultramarine Blue
Blue Green	Phthalo Turquoise Blue*	Prussian Green
Green	Bright Green	Permanent Green Light
Yellow Green	Cinnabar Green Light Extra	Yellow Green
Neutral Yellow	Yellow Ochre	Yellow Ochre
Neutral Dark Yellow	Raw Umber	Raw Umber
Neutral Orange	Burnt Sienna	Burnt Sienna
Neutral Red	Venetian Red	Venetian Red
Neutral Violet	Caput Mortuum Violet	Mars Violet***
Neutral Blue	Indigo	Indigo***
Neutral Green	Green Earth	Terre Verte
Black	Ivory Black	Ivory Black
White	Titanium White	Titanium White

* USE REMBRANDT

** USE OLD HOLLAND

*** USE THEIR ARTIST GRADE

Other Equipment

BRUSHES: We use filberts (flat brush with a rounded tip) of hog bristle, mongoose, or sable (most costly), in all sizes. Other shapes (rounds, flats, or brights) are not our preference—but they may be yours. If so, be sure to have them in a range of sizes.

MEDIUMS: We abstain from using a medium (such as linseed oil, which many artists mix with oil paint to alter its consistency). We find paint to be fluid enough without it. For subsequent painting sessions with the same canvas, we use Retouch spray first. This product will revive "dead" color in semi-dried paint. If the painting is completely dry, you can "oil up" with a very thin application of glazing medium, instead of Retouch. As a glazing medium, we recommend a mixture of equal parts stand oil and mineral spirits.

SOLVENTS: To clean brushes, we use turpenoid natural, followed by warm, soapy water. Turpenoid natural softens dried paint as well, and is completely nontoxic. It cleans palettes, too.

PALETTE: In the studio, we use plate glass. It cleans very easily with a knife, solvent, and paper towels, even when paint globs are completely dried over. A traditional wooden palette is also a good choice if properly maintained (mixing area cleaned and oiled after each painting session). Disposable paper palettes in pads are excellent for travel or the occasional painter.

CANVAS: Sold by the foot or as prestretched canvas; linen for experienced painters, cotton duck for students. Canvas boards, including miniature sizes for studies, are also useful.

PALETTE KNIFE: Since we use a palette knife to gently scrape the paint between painting sessions, the most useful knife is one with a thin, flexible blade about two inches long, with its handle raised from the blade.

INDEX

ABOUT THE AUTHORS

HongNian Zhang

HongNian Zhang is an American artist with a Chinese background. Born in Nanjing, his Western academic art training was at the Central Art Academy in Beijing, and later at City College in New York, where he earned his master's degree. Zhang is well known in the People's Republic of China as an award-winning oil painter, and his paintings, exhibited and acquired by China's Central Art Museum, are also in private and corporate collections throughout America as well as internationally. His works in the pages of this book were painted over the past fifteen years.

Zhang teaches oil painting and cast drawing at the New York Academy of Art in New York, and he is also on the faculty of the Woodstock School of Art in Woodstock, New York, where he and Lois Woolley share their lives and studio.

Lois Woolley

Lois Woolley, the principal writer of this book, is a professional painter specializing in portraiture. Her interest in portraiture stems from an abiding interest in people; they seem to her the ultimate subject matter. While her primary work is in commissioned portraits, she also paints figurative, landscape, and still-life subjects. She is a popular instructor at the Woodstock School of Art, teaching portrait painting from life.

A native of Washington, D.C., Woolley first studied painting there at the Corcoran School of Art, and later at the Art Students League of New York. Fellow of the American Artists Professional League, she also is an active member of other arts organizations. Her works are in collections throughout the United States and abroad, and her portraits can be commissioned through Portraits North of Lexington, Massachusetts.